Prolegomena
to the Study of Roman Art

PROLEGOMENA
TO THE
STUDY OF ROMAN ART

Expanded from "Prolegomena to a Book on Roman Art"

Otto J. Brendel

Foreword by Jerome J. Pollitt

NEW HAVEN AND LONDON
YALE UNIVERSITY PRESS
1979

Published with assistance from the Mary Cady Tew
Memorial Fund.

Designed by Thos. Whitridge
and set in Palatino type.
Printed in the United States of America by
The Vail-Ballou Press, Binghamton, N.Y.

Published in Great Britain, Europe, Africa, and Asia
(except Japan) by Yale University Press, Ltd., London.
Distributed in Australia and New Zealand by Book &
Film Services, Artarmon, N.S.W., Australia; and in
Japan by Harper & Row, Publishers, Tokyo Office.

Library of Congress Cataloging in Publication Data

Brendel, Otto, 1901–1973.
 Prolegomena to the study of Roman art.

 Includes bibliographical references and index.
 1. Art, Roman. 2. Art, Greco-Roman. I. Title.
N5760.B73 1979 709'.37 78-24455
ISBN 0-300-02268-9 cloth
 0-300-02372-3 paper

Contents

Figures

Foreword

Few scholarly articles in the field of ancient art have been more frequently sought after, cited, and reread than Otto Brendel's "Prolegomena to a Book on Roman Art," first published in the *Memoirs of the American Academy in Rome* in 1953. There are, I think, four features of Brendel's study that have made it of permanent value to scholars and students in the field of art criticism and account for the continuing interest in it over the past twenty-five years when so many other articles have faded into the quiet obscurity of library shelves.

First of all, the questions that the "Prolegomena" poses are fundamental ones, not only for the study of Roman art but for the study of the history of art in general. When Brendel asked, What do we mean when we speak of "Roman art"? he might equally well have been asking, as he himself points out, What do we mean by "Medieval," "Renaissance," "Baroque," or "modern" art? Roman art was produced by men of

many different nationalities and in many places out-
side of Rome. What makes it Roman? Was it simply
the art produced during a specific chronological phase
within a continuous "antique" tradition? If so, what
are the limits of that phase? Or was it the expression
of a unique ethnic or national character? If so, what
stylistic qualities of Roman art make its national char-
acter identifiable? And if there are stylistic qualities
that are peculiar to Roman art, what brought them
into being? An inevitable pattern of evolution? A
supraindividual will? Or the conscious choices made
by artists under the influence of specific historical
events and social conditions?

The "Prolegomena" provides an exhaustive analysis
of the answers given to these and related questions
since the Renaissance, and it sorts out and classifies
these answers in a particularly lucid way. This is the
second feature which accounts for the continuing ap-
peal of Brendel's study. It is a brilliant piece of intel-
lectual history.

A third feature is Brendel's own contribution to the
intellectual history that he traces. By the astuteness
and thoroughness of its evaluation of previous criti-
cism of Roman art, the "Prolegomena" became an im-
portant work of art criticism in its own right. Brendel's
insistence that precise definitions be established for
critical terms and that an effort be made to find rea-
sonable, plausible explanations for stylistic changes
often had the effect of bringing out, in his typically
gentle and constructive way, the vague and irrational
elements in earlier critical studies. Particularly good
examples of the power and clarity of his own judg-
ment are his critique of the concept that space is a

peculiarly Roman characteristic in relief sculpture, and his critique of the ideas that inevitable evolution or a supraindividual will are creative agents in the development of artistic styles.

The last feature that has made the "Prolegomena" of basic and abiding importance is that it seems to have put into perspective all the possible ways in which one can define *Roman art*. It can be viewed as a particular chronological phase in a longer and broader development or evolution; or as an expression of the character of a nation; or as the outcome of the interaction and competition of two conflicting tendencies (the dualistic theories); or as the assemblage of a number of distinct styles unified by their use in a particular cultural milieu. At the conclusion of his analysis of critical ideas about Roman art proposed up to the year 1926, as he was about to summarize what had been said between 1926 and 1953, Brendel wrote ". . . one is not likely to meet many basic concepts which cannot be readily understood as the natural consequences, or variations, of those already explained." This same remark might also be applied to the years 1953 to 1978. In this twenty-five-year period a number of important general histories, as well as a great many limited special studies, have appeared, and while not all of these have made an attempt to define what is characteristic of Roman art, those which have will be seen to fit quite comfortably into the categories established by Brendel. The most notable development in the criticism of Roman art in recent years has been the recrudescence of an approach whose essential features were first clearly delineated by Gerhard Rodenwaldt and which Otto Brendel assigned to his dualistic

category. The proponents of this approach, of whom
the most influential has been Ranuccio Bianchi Ban-
dinelli in his two substantial volumes in the *Arts of
Mankind* series, see the peculiar character of Roman art
as stemming from the contrast and contest for domi-
nance between a "patrician" taste, based on a learned
appreciation of Classical Greek art among the Roman
upper classes, and a "plebeian" taste, which reflected
the native Italic sensitivities of the lower and middle
classes of the Roman world.[1]

"Roman Art in Modern Perspective," the second,
and previously unpublished, essay in the present vol-
ume, was written in 1969 and was intended to evalu-
ate the directions in which the study of Roman art had
been moving, or ought to have been moving, in the
fifteen years following the publication of the "Prolego-
mena." In this review Brendel offered a few of his
own views about problems raised in the "Prolego-
mena," e.g., the chronological limits of Roman art, its
apparently dualistic (public and private) nature, and
the role and meaning of Greek elements in it. He also
pointed out, and made some useful suggestions about,
areas where further research might prove helpful in
the quest to define the nature of Roman art, e.g., the
non-Greek aspects of Roman painting and the role of
allegory in Roman art. It is clear from this later essay
that Brendel felt a proper understanding of the nature

1. Ranuccio Bianchi Bandinelli, *Rome: The Centre of Power* (Lon-
don and New York, 1970), especially pp. 51–105; *Rome: The Late
Empire* (London and New York, 1971). Bianchi Bandinelli's ap-
proach is endorsed by Richard Brilliant, *Roman Art from the Repub-
lic to Constantine* (London and New York, 1974), especially pp.
17–18.

of Roman art could be arrived at only by appreciating its diverse and sometimes contradictory strains rather than by imposing, a priori, some theoretical notion of *Romanitas* upon it.

Since "Roman Art in Modern Perspective" was designed as a supplement to the "Prolegomena," it is being published here in spite of the fact that it is in some respects an unfinished work. Because of other commitments Otto Brendel had to put the essay aside for several years and had not been able to add the final touches to it when he died in 1973.[2] The text of the article is printed essentially as it was first written, with only minor editorial alterations. The references in the notes, as explained in the acknowledgments, have been assembled by Maria Brendel.

JEROME J. POLLITT
Yale University

2. An appreciation of Otto Brendel's life and scholarship can be found in *In Memoriam Otto J. Brendel, Essays in Archaeology and the Humanities*, ed. Larissa Bonfante and Helga von Heintze (Mainz, 1976), pp. ix–xiv.

Acknowledgments

Otto Brendel had not finished writing all the footnotes for the essay "Roman Art in Modern Perspective" when he died in 1973. The task of adding notes to the text, wherever it seemed possible and reasonable to do so, has been undertaken by Maria Brendel. Mrs. Brendel, who has been the overseer of the publication of this volume, wishes to express particular thanks to Dr. Giuseppina Cerulli Irelli for assistance in securing the necessary references. She is also grateful for assistance provided by Mr. Stephen Zwirn and friendly advice by Professor P. H. von Blanckenhagen.

Abbreviations

AA	Archäologischer Anzeiger
AJA	American Journal of Archaeology
AnnIst	Annali del Istituto di Corrispondenza Archaeologica
Art B	Art Bulletin
BCH	Bulletin de correspondance hellénique
BMQ	British Museum Quarterly
Bonn Jhb	Bonner Jahrbücher
CAH	Cambridge Ancient History
CR	Classical Review
GBA	Gazette des beaux-arts
GöttNachr	Nachrichten von der Gesellschaft der Wissenschaften zu Göttingen
JdI	Jahrbuch des deutschen archäologischen Instituts

JOAI	Jahreshefte des österreichischen archäologischen Instituts
JRS	Journal of Roman Studies
MAAR	Memoirs of the American Academy in Rome
MdI	Mitteilungen des deutschen archäologischen Instituts (1948—)
MemLinc	Memorie della R. Accademia Nazionale dei Lincei
MJ	Münchener Jahrbuch der bildenden Kunst
RivIstArch	Rivista del R. Istituto d'Archeologia e Storia dell'Arte
RM	Mitteilungen des deutschen archäologischen Instituts, Römische Abteilung
StEtr	Studi Etruschi

I
Prolegomena
to the Study of Roman Art

The Problem of Roman Art

History has imparted a curious double meaning to the words *Rome* and *Roman*. If we say "Rome," we refer at the same time to a city and a state. The city lies within geographically well defined boundaries, between the Alban hills and the mouth of the Tiber in central Italy. The state grew far beyond these limits and eventually became the Roman empire. The city of Rome still exists. The Roman state on the other hand belongs to the past, so that we have become accustomed to speak of the Roman empire as a historical period. Yet all these complex facts, the city and the state, the empire and its time in history, we call by the same name, Roman. Our very language becomes a potential source of confusion with regard to everything Roman, and from this condition art is not exempt.

The salient point is that all accomplishments to which Rome lent its name are not Roman in the same sense nor to the same degree. For instance, Roman history traditionally comprises the total evolution of the Roman state from its origin to the end of the empire and consequently much more than a mere city history of Rome, while the medieval and later affairs of the city are not usually included in this term. Roman law was eventually collected and codified at the behest of a Byzantine emperor, Justinian; yet it is Roman. The ancient bridges and aqueducts of Spain

and southern France were built under the Empire, though probably not by natives of Rome only, nor can it be asserted that the technical knowledge employed in these structures was all owed to Romans. Yet to us these buildings constitute monuments of Roman enterprise and engineering. On the other hand, rather paradoxically, the most intimate and direct expression of the Roman spirit, its language, was never called Roman. It is Latin. Thus the credit for this accomplishment is given not to Rome but to a regional civilization, now extinct, of which Rome once formed a part.

We must understand from the outset that the same uncertainty is bound to reappear in the study of Roman art. It has indeed determined the course of these studies, especially in their latest stage during the past fifty years. The name itself, *Roman art,* requires explanation. What do we really mean by this expression? Conceivably we may so designate the art of the city of Rome in the same sense as one speaks of "Roman" Baroque. But we may also with the same expression refer to the art of the Empire and call Roman all works of art produced during the imperial epoch anywhere. Again, the attribute "Roman" may be limited to such works of art as were produced by Romans only, not by Greeks working in Rome or under the Empire, or a certain type of art may be defined as stylistically Roman, as another type is Gothic, regardless of its place and time of origin. The problem is inherent in all investigations stipulating or negating the existence of a Roman art as the case may be. Yet few writers have stated this expressly. Alois Riegl, for one, per-

ceived the necessity of explaining the term *Roman* in the title of his *Spätrömische Kunstindustrie*. He declares in the introduction: "In selecting the word 'Roman' instead of 'antique,' I had in mind the entire Roman empire but not—as I wish to emphasize strongly from the outset—the city of Rome or the Italic people or the nations of the western half of the empire only."[1] This, of course, represents only the deliberate choice of a single writer; other definitions are just as possible.

Three characteristic problems arise from the peculiar conditions of Roman art. One regards its *esthetic evaluation*, which has proved remarkably uncertain almost from the beginning; the second its *historical development*, about which very little authentic documentary evidence has come down to us. Obviously, moreover, by modern standards, in order to deal with either one of these questions, we must first decide what to call Roman. Both involve the initial, *terminological* difficulty. Past experience has amply shown that these three questions are closely connected with each other. Together they form the "Roman problem" in the modern literature on art.

All three loom large in the recent discussions of ancient art. They have stimulated factual research and theoretical thought alike. Some of the most brilliant recent contributions to art historical method and the critical analysis of art have been dedicated to the Roman problem. Indeed, this controversy represents a characteristically modern interest, as one can sense from its growing intensity. Roman art, now more than

1. A. Riegel, *Die spätrömische Kunstindustrie* (Vienna, 1901), p. 10. (Author's translation.)

ever, constitutes a controversial matter. We still have
no real mastery of all the seemingly disparate and
often uncoordinated materials which claim our atten-
tion as "Roman art." We lack ascertained facts, and we
also lack adequate critical tools to deal with the variety
of these materials. It has proven especially difficult to
evolve those generally valid, comprehensive principles
which seem required in order to separate effectively
all works of Roman art from the other arts with which
they are so closely allied, the Etruscan and the Greek.

Numerous factual discoveries mark the progress of
knowledge through the past hundred years of archaeo-
logical research. Roman art has had its share of these
discoveries; nevertheless, the recent discussions in
this field have probably made their greatest contribu-
tion by bringing into focus the general problem of
Roman art. As to the answers suggested, no agree-
ment is yet in sight. At least it is evident today that
one cannot write a history of Roman art, as one can set
out to write a history of Egyptian or Greek art, by
starting from a recognized, coherent body of works of
art, which present an obvious unity of style, of inten-
tions, and of means of expression. The terms *Egyptian,
Greek* have an established meaning in the field of art;
the meaning of the word *Roman* cannot so be taken for
granted. The unity of Roman art is not obvious as a
style or approach to artistic representation, like the
Egyptian style. If a similar inner coherence existed at
all in Roman art connecting its various manifestations,
it must still be uncovered in the diversity before us.
The decision is mostly up to the modern student, as to
what to call Roman and why, and the burden of proof
rests on the critic. A history of Roman art cannot

merely present and explain; it must first define its subject matter.

In this respect the case of Rome is not unique in the history of art. Critics of Renaissance art likewise must define the term *Renaissance* and demonstrate its usefulness as a historical category, before they can deal with the various productions of this period as a closed group. Their task may be less difficult than the problems presented by Roman art, insofar as the nucleus of Renaissance art, in Italy at least, defines itself well by way of its style and intellectual climate. Questions arise, however, as to the limits of the category. Shall we say that Renaissance art begins with Giotto or Masaccio? Is it a purely Italian movement or are we justified in speaking of a northern Renaissance? What modifications are needed to impart to the latter term a meaning consistent with reality? The answers to these questions are not self-evident; they require clarification. Similar questions are in place, and even more pressing, with regard to Baroque art. Where does it begin? Where are its limits? What, in fact, is Baroque, a historical period or merely a trend within a historical period, the seventeenth century? Such questions are not unlike those which Roman art puts before us. The term *modern art* is similarly ill-defined and in need of discussion, in spite of the fact that its object forms a part of our contemporary existence. Not all contemporary art is modern. In each of these instances the validity of a critical or historiographic category must first be proven, and its precise limitations defined before actual materials can be ascribed to it. We must draw the line between that which is or is not modern or baroque in art. So we must decide what we wish to call

"Roman." The distinction expresses our own critical evaluation of a work of art. Additional examples are not hard to find in the history of art.

Still, however, the puzzle of Roman art would remain. For one thing, most of the arguable, critical classifications of the kind just mentioned result from conditions typical of the postclassical periods, Medieval or later. In these periods it surprises us less that artists choose freely between various modes of expression. In ancient art we are accustomed to find the distinctions much more sharply drawn—more objectively, it would seem. The style of Egyptian paintings or statues, for instance, is highly characteristic. It is easily recognized, because its approach to artistic representation is permanent as to fundamental principles and exclusive of all other ancient styles. As a rule there can be little doubt whether or not a work of art is Egyptian. Greek art, similarly, in review exhibits a distinctive and self-contained character, in spite of the evolutionary energy which led it through so many different phases from the archaic to the Hellenistic. Yet even in antiquity instances occur which may cast a doubt on the certainty with which we use these historical categories. Greek artists worked for Persians. Shall we call the results Greek or Persian art? Intermediary arts existed between the great styles of Egypt, the Near East, and early Greece, like the art of the Phoenicians. Such mixed styles are now commonly treated with disrespect, as lacking in originality. But they, too, had their share in the growth and expansion of our civilization. An objective evaluation of the archaic Phoenician style has yet to be given.

However, all these were but minor incidents in the

early history of Mediterranean culture. What makes the case of Roman art so baffling is the fact that in this one instance we are confronted with a main branch of ancient art, of long tradition and extraordinary productivity, yet surprisingly deficient in those exclusive, constant, and definite stylistic traits which differentiate most other ancient arts from each other like so many different languages. Moreover the Roman accomplishments in other fields are both distinctive and outstanding. One expects to find a Roman art comparable in importance to the Roman military achievements or government administration, which built the famous Empire, or to the classical Latin literature which infused the political structure with a spiritual meaning of its own. Instead, one finds an art of quite uneven tendencies, uncertain in origin, oscillating between a "neoclassic" acceptance of Greek standards and an often crude "popular" realism, and eventually issuing in the seemingly "anticlassic," formal rigidity of the late Roman style.

The dilemma is critical as well as historical. When modern criticism wishes to do justice to a display of art so contrary to modern expectations, it is first of all confronted with the problem of esthetic evaluation. But this cannot long be separated from the historical problem of evolution. Therefore, to reconstruct the evolution of Roman art as a process in history has long been, and still is, a pressing task. And this task, in turn, leads to the problem of definition, as explained above. We must define what we mean by Roman art. This is the terminological problem. Recent criticism has tended to concentrate especially on the question what, precisely, is Roman in Roman art.

The History of the Problem

One must know these three aspects of the problem—
the esthetic, the historical, and the terminological—in
order to understand the modern literature on Roman
art. All three undoubtedly derive from the real condi-
tions of Roman art. Yet only gradually have modern
students and critics become aware of these conditions.
Each one of these questions, though inherent in the
material, moved at one time within sight of modern
criticism, and upon its discovery gave rise to a fresh
approach to Roman art. Thus the historical problem of
Roman art was first formulated during the Renais-
sance; the esthetic evaluation became problematic
during the seventeenth and eighteenth centuries; and
the terminological definition of a Roman style con-
cerns the most recent research. These changes of view-
point each time accompanied an increase of factual
knowledge and a more direct contact with the original
materials. They are also symptomatic of other more
general changes in European thought. In this, as in
other fields, it appears that discoveries are not made at
random but when the time has come for them.
Through the past centuries the varying reactions to
Roman art have faithfully followed not only the domi-
nating preferences of taste but the development of
ideas in general. In this way, from time to time, by the
intuition of one writer or the efforts of a whole group
of scholars, the entire problem has been reformulated
and recast in a radical manner. Whenever this has
happened, the result has been a new theory of Roman
art. In what follows we shall briefly record the decisive

steps in this sequence of theoretical approaches from the fifteenth century onward. The fundamental ideas incorporated in the earlier approaches are not as yet extinct, nor is their usefulness exhausted by the observation that some theories owe their origin and impact to intellectual constellations different from the present.

The Renaissance

Two peculiarities seem especially remarkable in the attitude of Renaissance theorists toward Roman art. One is the absence of an effective distinction between Greek and Roman. To the generations who first began to form the concepts of our history of art during the fifteenth century classical antiquity appeared as a continuous whole. As such, the "ancient manner" was *toto genere* opposed to the "modern." Thus one reads in Ghiberti's second commentary that ancient art ended under Constantine. For 600 years after this event no images were permitted, and the knowledge of art fell into oblivion. After this long interval the Greeks—that is to say the Byzantine revival in Tuscany—made the first feeble attempts at creating anew the art of painting. For the art which then began, the term *modern* came in use soon after Ghiberti.[2]

2. *Lorenzo Ghibertis Denkwürdigkeiten (i commentarii)*, ed. J. von Schlosser (Berlin, 1912), I, p. 35. Cf. von Schlosser's explanation of this important passage, written between 1447 and 1450, ibid., II, 108. Ghiberti merely applied to art the general tenor of the Renaissance, which emphasized the contrast between ancient and modern [medieval] modes of life and learning. Medieval learning instead was permeated with a feeling of historical continuity. Only the Renaissance sought to "revive" something which in the meantime had been lost, be it the classical humanism of Cicero or the

One deals here with a fundamental concept of criticism. Its basis is a distinction not between two equivalent styles but between an earlier, better art (the "ancient") and an "uncouth" recent art (the Byzantine or Italo-Byzantine). One will notice, however, that with this art-critical contrast a historical concept is closely allied, the idea of a decline of the arts. This is the second point which requires our attention.

Complaints about an alleged decline of the arts are not uncommon in certain Latin authors widely read in the Renaissance, such as Pliny, Vitruvius and others.[3] The innovation of the Renaissance lies in the fact that the esthetic belief in a decline of art has been incorporated in a full-fledged historical theory, as we find it in Ghiberti. This is not true of the Latin writers on art. The brief passage in Ghiberti is significant, because it contains the nucleus of a consistent *history* of art with a division into three main epochs: the ancient, the intermediary (our Middle or Dark ages), and the new primitivism (neo-Byzantine), from which Giotto was first to liberate the arts. Critically, the ancient period is regarded with admiration, the second as a mere vacuum, and the third as an archaic stage eventually overcome (by Giotto).

This critico-historical scheme remained in force

classical Latin of the Augustan era. This was the original attitude of Petrarch. Cf. L. Olschki, *The Genius of Italy* (New York, 1949), 208: "In many letters and poetic allusions Petrarch elaborated the contrast rather than the affinity between his age and the ancient world. He ignored whatever had happened between the end of the Roman empire and his own time. In that development he saw only abuses, barbarism, and errors. . . ."

3. See below, p. 92.

throughout the Renaissance, and is even now not entirely invalidated. Our own concept of the Renaissance was fashioned according to this pattern. This is not to say that the scheme is without foundation in reality, defective though it be with regard to details. The matter cannot be further discussed in the present article, where we must concentrate attention on the influence which this example had on later histories of Roman art. The important point is that we deal with a theory which in historical terms stipulates a decline of the arts. The next question is unavoidable: Where, when, and why did this "decline" actually occur? Ghiberti presents the Renaissance answer to this question: the decline of the arts occurred after—not during or before—the Roman period, in the Dark Ages.[4] Others later asked the same question but gave different answers.

During the Renaissance, however, the state of this problem remained rather constant. Antiquity was generally an indivisible entity, of which Greek and Roman were only two different aspects or subsequent

4. That this was the common opinion can be seen from the somewhat later treatise on architecture by Filarete, completed in 1464; see *A. A. Filarete's Tractat über die Baukunst*, ed. W. von Oettingen (Vienna, 1896), p. 2. Filarete explains the decline of architecture in some detail as a consequence of a general decline of education (the "dark ages") plus the—unfortunate—influence of the modern (that is, Gothic) style of central and western Europe (French and German); op. cit., 428 f. This is much the same thought as in Ghiberti, although Filarete dates the beginning of the Renaissance (as we call it) later than Ghiberti, around 1400; ibid., 428. In other words, no sooner was the concept of decline generally accepted, than its specific application to history proved an arguable point.

phases. The downfall of the arts, or of all higher culture, came with the end of antiquity. Greek and Roman together formed the classical age. What mattered was not the differentiation between these two phases of antiquity but the greater contrast between "ancient" and "modern." Because of this consistent if simplified view, there could be little doubt about the esthetic evaluation of Roman art. The prestige of Roman art was high, simply as a part of the general reaction against the nonclassical modern arts, Byzantine and Medieval.

A succinct summary of this situation is found in Vasari, who in purely theoretical fashion assumed a constant progress of the arts from the beginning to the end of antiquity. "The Romans may truly be said to have gathered the best qualities of all other methods and united them in their own, to the end that [the Roman 'manner' or style] might be superior to all, nay, absolutely divine, as it is." (Biography of Andrea Pisano.) In the same passage he gives a hint for the first time of the problem awaiting the future historians of Roman art. For in writing these sentences, Vasari felt compelled to qualify his own use of the term *Roman* by stating: "I call those Romans, who, after the subjugation of Greece, repaired to Rome, whither all that was good and beautiful in the whole world was then transported."[5]

5. For the entire passage, cf. E. H. and E. W. Blashfield and A. A. Hopkins, *Lives of Seventy of the Most Eminent Painters, Sculptors and Architects, by Giorgio Vasari,* I (London, 1907), pp. 82 f., from which the above translation was quoted.

The Theory of Growth and Decay

Only when Roman art was viewed in contrast rather than unity with the Greek, did its esthetic evaluation become problematic. Practical acquaintance with its productions could not fail to disclose this contrast, nor could the contrast between early and late Imperial art be long disregarded.[6] Even before such acquaintance could be based on sufficient data and materials for comparison, it was possible to anticipate the necessity of a distinction between Greek and Roman. Greece was the older culture, Rome only the follower. Though both "classical," they were not necessarily equivalent. The relation between them, once formulated, became an open question.

We find an early and telling symptom of this im-

6. In the seventeenth century, as in the sixteenth, we find that professional criticism often dispenses with stylistic distinctions which we find *de rigueur* in Roman art. Cf. the anecdote which Bernini told about Michelangelo who, "at first seeing the Danae of Titian, exclaimed that had the Venetians only known how to draw, no one would look at the works of the Roman school; but that, on the other hand, it was only in Rome that they had such a model as the Trajan column"; E. Strong, *Roman Sculpture* (London and New York, 1907) pp. 3 f. Obviously to Michelangelo and Bernini the reliefs of the Column of Trajan were simply examples of good design, that is, valid without qualification of style, artistic medium, or content. The underlying theory still is the old, Renaissance view of an undivided "ancient manner"—beyond the distinction between Greek and Roman, or Roman classical and late Roman. For Renaissance drawings of the Column of Trajan cf. R. Paribeni, "La colonna Trajana in un codice del Rinascimento," *Rivista dell'Istituto di Archeologia e storia dell'arte* 1 (1929), 9 ff.

pending change of attitude in a letter by La Teulière, until 1699 director of the French Academy in Rome. This institution was expressly dedicated to the study and copying of works of art in Rome. However, as early as 1696 La Teulière suggested that a similar school be opened in Athens, giving the following reason: "As the fine arts came to Italy from Greece, one would then [if an academy were instituted in Athens] see things at their origin; this being true of both architecture and sculpture, of which beautiful remains are still there according to what people say, especially bas-reliefs, etc."[7] Here Roman art, far from being "superior to all," as it seemed to Vasari, holds no more than the second place after the Greek. The trend is essentially unfavorable to Roman art, as its subsequent record has amply shown.

This view, more recent than the one which it opposes, took some time to develop. The interest in antiquity during the seventeenth and eighteenth centuries concentrated primarily on those voluminous publications of ancient monuments with engraved illustrations, which on a truly encyclopedic scale for the first time demonstrated the wealth and variety of the extant remains. Collected with a scholarly zeal for compilation and information, though frequently without adequate critical sense, these materials with all their errors and falsehoods offered a lasting stimulus to research and a challenge to the critical genius of generations to come. Because of their richness of content and a certain flair for the uncommon and bizarre,

7. Translation by the author. The passage is rendered in full in H. Lapauze, *Histoire de l'Académie de France à Rome*, I (Paris, 1942), pp. 85 f.

these books are still profitable to consult. In 1749 excavations started at Herculaneum, adding new discoveries to the materials already known. These too were soon made available by way of a generous publication.[8] All these scholarly activities effected a real progress in the assembling of ancient materials, but they contributed little to the critical problem of art proper. Indeed theoretical discussions of art remained mostly beyond the scope of this literature, which was designed to provide factual information. It must not be assumed, however, that leading ideas were altogether lacking among the antiquarians. An example of immediate interest may be cited from the most comprehensive, indeed encyclopedic, work of this class dealing with the religion and material culture of antiquity, de Montfaucon's *L'antiquité expliquée*, published in 1719.[9] In the preface to volume 1 the range of the entire project is explained as follows: "This work comprises what has been called 'la belle antiquité' which, though badly shaken since the third century, is assumed to have definitely ended at the time of the younger Theodosius."[10] The definition of the late classical period—the period of decay—corresponds to the historical concept, which afterwards was so impressively set forth in Gibbon's *Decline and Fall of the Roman Empire*.[11] It is essentially the Renaissance concept as we found it in Ghiberti. There is but one dif-

8. *Delle antichità di Ercolano*, vols. 1–9 (Naples, 1757–1831).

9. B. de Montfaucon, *L'antiquité expliquée et représentée en figures* . . . , 5 vols. in 10 books (Paris, 1719).

10. Op. cit., I, p. xiv.

11. E. Gibbon, *History of the Decline and Fall of the Roman Empire*, 6 vols. (London, 1776–88).

ference. Before the final downfall a period of decline is now recognized within the ancient period itself. This corresponds to our use of the term *late classical*. However, one cannot help feeling that Montfaucon uses rather guarded language in introducing this topic. There is a reason. The concept *la belle antiquité*, meaning the classical age, carries an esthetic connotation which he distrusts. He feels obliged subsequently to point out that to the following period of "barbarism" humanity owes a number of vital technical inventions like windmills, watermills, and others unknown to *la belle antiquité*.[12] Without examining the arguable details of this passage, we can accept it as an indication that the leading idea of Montfaucon was a general anthropology of the ancient world. From the viewpoint of a general anthropology one may indeed doubt that the idea of the decaying antiquity constitutes a useful historical term or even a usable division. The general civilization of western Europe remained in its late-classical stage much longer, perhaps until the ninth or tenth centuries. Here appears not only the difficulty of limiting the classical period toward its lower limit, the Middle Ages, but the concept of the decline itself as a complete disintegration of culture becomes questionable.

It is evident that all these various trends of thought are connected by one basic concept. Their determining idea was that common pattern of historiography, which we first recognized in the early Renaissance and whose unique effect on later art criticism now becomes quite apparent. We call it the theory of the growth and decay of cultures. In one way and another

12. Montfaucon, op. cit., p. xv.

all the pros and contras here recorded refer to this basic idea. The same idea became the central concept of a book which here requires special attention, because it exercised a lasting, indeed determining, influence on all later criticism of Roman art, the *History of the Art of Antiquity*, by J. J. Winckelmann.[13]

Written and published in the atmosphere of eighteenth-century modernism with its rapid increase of knowledge and rising controversies, this book owed its extraordinary success chiefly to the synoptic power of its author. Winckelmann fused the methods and viewpoints of several disciplines into one, thereby creating a new discipline, the history of art.[14] His first concern was with art criticism, in which field he believed he had a special message.[15] He was not an antiquarian, yet possessed the knowledge of one; he

13. J. J. Winckelmann, *Geschichte der Kunst des Alterthums* (Dresden, 1764).

14. A history of art existed in antiquity, as we know from extant fragments. It probably consisted of artists' biographies, similar to those of Ghiberti, Vasari, and other Renaissance writers, but it was also concerned with the evolution of artistic theory. Cf. below, nn. 111, 113. What Winckelmann had in mind was an entirely different idea, a history of styles. From the outset he contrasts his "history of art" with the earlier "histories of artists"; the latter are not his concern. See preface, *J. J. Winckelmann's Geschichte der Kunst des Alterthums*, ed. J. Lessing (Berlin, 1870), p. 5. All following references to Winckelmann's *Geschichte etc.*, are quoted from this edition, which is a reprint of the first edition of 1764. Translations by the author.

15. Winckelmann was a relentless critic both of the naturalistic art theory of his time and the mannerisms of Baroque and Rococo art. For a preliminary synopsis of his theoretical views, see G. Baumecker, *Winckelmann in seinen Dresdner Schriften* (Berlin, 1933), esp. pp. 105 ff.

knew Greek as well as Latin, and, with a philologist's independence of judgment, schooled in textual criticism, he combined an original grasp of literature, especially Homer. With regard to general chronology and the style of individual works he was bound to err often, as indeed he did. Yet he established the development of classical art by gradual changes, and was able to indicate the chief periods of this process. His methodical aim was a concordance between literary evidence, dated monuments including coins, and the many undated relics of ancient art. He understood that a realistic examination of the monuments was required for this task, and spurned the theorists and desk-antiquarians who let themselves be deceived by faulty engravings and clever forgers. His literary style is informed with a personal, almost aggressive directness; his descriptions are enlivened by numerous original remarks and happy associations, constantly reminding the reader that every work of art is first of all an individual.[16] Yet all these varied intentions, ideas, investigations, and observations had to be inscribed, as within a forming and determining contour, in a concept of history. This is what Winckelmann set out to achieve. He thought of history as a unifying principle by which the individual phenomena can be collected and arranged, history not understood as a mere sequence of events but as a systematic and intelligible order of related materials, a *Lehrgebäude*. He explains his project thus in the preface:

> The history of art (sc. in antiquity) must teach us the origin, growth, change and decline of art together with the

16. For a useful list of earlier literature and opinions about Winckelmann, see op. cit., pp. 148 ff.

various styles of peoples, periods and artists, and it must prove these propositions, as far as possible, with the help of the remaining monuments of antiquity.[17]

Winckelmann's evaluation of Roman art must be understood against this background of ideas. In two respects, at least, it was negative. The first point concerns his concept of history. As an art critic, not unlike the Renaissance artists, Winckelmann was inclined to view classical art as a homogeneous unit in sharp contrast with the art around him, i.e., the late Baroque styles which he vehemently criticized. In comparison with works of this kind even the late examples of ancient art "to the downfall of art" seem praiseworthy.[18] This view he shared with others before and beside him.[19] On the other hand, Winckelmann formed a rather precise idea (or ideal) of the special qualities which in ancient art compared so favorably with the "modern." These qualities are not equally present in all ancient works. He was therefore led to give preference to the periods of ancient art in which these qualities, as he saw them, were most purely represented. In recognizing important qualitative differences between the various periods or styles of ancient art he was, moreover, supported by ancient writers, notably by Pliny. Thus Winckelmann's critical approach brought the inequality of the remaining works of ancient art to

17. *Geschichte der Kunst*, p. 5.

18. "About the Good Taste, Preserved even during the Decline of Art." (Chapter heading in *Geschichte der Kunst*, p. 164.)

19. See above, Ghiberti and others. As to Winckelmann's contemporaries, cf. G. Baumecker, op. cit. (above, n. 15), esp. pp. 57 ff., regarding the "simplicity" of ancient art.

the fore and frequently gave it more importance than the common characteristics. The full strength of ancient art, the classical style proper, was now found restricted to a limited time within antiquity corresponding approximately to the fifth and fourth centuries B.C. In other words, Winckelmann saw the old theory of a growth and decline in the arts most strikingly confirmed by his own findings. But he gave to this theory a different emphasis. The decline of art so regarded began long before the end of the ancient period; it is a historical process within antiquity itself. In Winckelmann's history of art, the period of decline starts after the death of Alexander. All Hellenistic and especially Roman art according to this scheme belongs to the declining stages of antiquity.

In the passage in which Winckelmann expounds this theory one finds a most interesting remark. The evolution of Greek art, "especially sculpture," is divided into four periods of style, two of rising and two of declining tendency. This stated, Winckelmann continues: "The fate of art in modern times with regard to its periods equals that of antiquity; in it, likewise, four decisive changes have occurred. . . ."[20] One sees how the historical concept has grown in Winckelmann's thought. In recognizing the parallelism between the ancient and postclassical history of art he anticipates far more modern concepts, such as the "Cycles of Taste," to use a contemporary formula.[21]

20. *Geschichte der Kunst*, p. 165. The section entitled "The Growth and Decline of Greek Art" likewise starts with an explanation of the four periods, op. cit., pp. 144 ff.

21. F. P. Chambers, *The History of Taste: An Account of the Revolutions of Art Criticism and Theory in Europe* (New York, 1932).

With Winckelmann the modern stage of the obvious trend toward a systematization of history comes within sight. It should be noted, however, that Winckelmann wanted no more than to state an observation. There is no indication that for him this parallel between ancient and postclassical evolution also implied a lawful sequence (as in Wölfflin) or a biological necessity (as in Spengler).

The second point to be stressed here regards the question, likewise discussed by Winckelmann, whether or not a specifically Roman style can be identified in art. Winckelmann gave a negative answer: there is no specific Roman style. He viewed classical art (as he viewed the Renaissance) as a continuous evolutionary process and saw no grounds for a differentiation between a Greek and a Roman style.[22]

It seems that in Winckelmann's historical scheme Roman art of the empire generally coincides with his assumed fourth period, called "the style of the imitators and the decline and downfall of art,"[23] but the chronological divisions between the four periods are

22. *Geschichte der Kunst*, 191, chapter heading: "Erroneous Opinion, regarding a Specific Style of [Roman] Art."
23. Op. cit., p. 157, chapter heading. The low estimation of the "Nachahmer" in this chapter contrasts with Winckelmann's own insistence, on other occasions, on "Nachahmung der Alten." Probably the difficulty is merely semantic, and Winckelmann had in both cases a different kind of "Nachahmung" in mind, though he used the same word; cf. Baumecker, op. cit. (above, n. 15), pp. 41 ff. But the chapter in *Geschichte der Kunst* shows that the idea of Greek art as the original was bound to have an unfavorable effect on the evaluation of Roman art. So Winckelmann already in the *Gedanken über die Nachahmung der griechischen Werke*, of 1755; see Baumecker, op. cit., p. 40.

not always clearly stated. Nevertheless in chapters IV
and V of the second (chronological) part of the *Ge-
schichte der Kunst* standard works of imperial art are
discussed with high praise, although, character-
istically, the chapters are called "About Greek art
under the Romans and the Roman Emperors," and
"Downfall of Art under Septimius Severus."[24] The
term *Roman art* is avoided. Winckelmann realized that
entire classes of art are typical of Roman art, such as
the imperial and funeral portraits and the sarcophagi;
however, he showed little interest in them.[25] His
chapter "History of Art in Rome" presents a still use-
ful collection of literary notices regarding works pro-
duced in or transported into Rome, but its scope is
limited to the Republican period.[26] Etruscan art is
treated separately.[27]

According to the plan of his book, Winckelmann
scattered his statements and observations about
Roman art over the various sections instead of collect-
ing them in a continuous report. Frequently alien ma-
terials are included with the chapters on Rome. Yet
with all its deficiencies, the *Geschichte der Kunst des Al-
terthums* gives us the first outline of a history of
Roman art in modern terms, as it sets the first example
of a modern history of Greek art. For more than a cen-
tury afterward archaeological research was occupied
with sifting and enriching this impressive material.
Gradually the outline was filled in with more and
more reliable detail.

24. *Geschichte der Kunst*, pp. 248 ff.
25. Op. cit., p. 163.
26. Op. cit., pp. 131 ff.
27. Op. cit., pp. 72 ff.

Reevaluations

It is still possible to hold Winckelmann's view that Hellenistic art marks the beginning of a decline, and that a truly Roman art never existed because there was no Roman style.[28] Nevertheless today his influence is not felt so directly. It was superseded during the nineteenth century by an important change of taste and intellectual attitude as well as a new development in the arts. Largely as a result of these changes the case of Roman art was reopened toward the end of the century by the two Viennese art historians, A. Riegl and F. Wickhoff. The event marks a new phase in a controversy, then already of old standing.[29]

Perhaps the most obvious change was one of method. For the first time we see modern techniques of art historical analysis set to work on the Roman problem. In the minute examination of vast, disparate materials the free, if somewhat improvising, judgment of the cavalier-connoisseurs, eighteenth-century style, was replaced by more objective criteria. Like a science, the history of art was now based on the observation of multiple cases. Archaeology had begun to establish a firmer foundation of factual and chronological knowledge, although both Riegl and Wickhoff complained that not enough of this work had been directed toward Roman studies, and their own dating

28. See below, p. 72.
29. A. Riegl, *Stilfragen* (Berlin, 1893); F. Wickhoff and W. Ritter von Hartel, *Die Wiener Genesis* (Vienna, 1895), pp. 1–96; A. Riegl, *Die spätrömische Kunstindustrie* (Vienna, 1901).

of the monuments often shows that the complaint was not without substance.[30] But more important than the details is the insistence in the works of both scholars on new categories of esthetic description and comprehension.

Here one senses the impulse of contemporary, particularly impressionist, painting. A characteristic of late-nineteenth-century theory is the specializing emphasis on "pure seeing" as the true faculty of the artist, which with all ensuing problems became the origin of modern art. Especially Riegl never tires of asserting that works of ancient art, like all others, must first of all be judged by their "material appearance in contour and color, on the plane and in space."[31]

In the combination of fresh esthetic concepts with a vigorous historical analysis lies the chief advantage of this approach. The novelty of the theoretical interests could not fail to alter the very language of art criticism, which now aspires to increasing philosophical and scientific precision. The results are of fundamental importance even today, although for the unprepared reader the terminology occasionally requires explanation.

Every art testifies to an act of choice, which is best

30. For instance, Wickhoff's erroneous dating of the so-called Spada-reliefs; cf. J. Sieveking, "Das römische Relief," *Festschrift Paul Arndt* (Munich, 1925), 23, 29 f. For a list of chronological assumptions in Riegl, since found untenable, see G. v. Kaschnitz-Weinberg, *Gnomon* 5 (1929), pp. 212 f.

31. Quoted from the characteristic passage in *Die spätrömische Kunstindustrie*, n. 1. (Author's translation.)

understood if we realize that one and the same idea can often be expressed in several different manners. Hence the value of comparisons for the understanding of art. Throughout the nineteenth century, Roman works were commonly compared with Greek art. This time the case was different. The original concern of Wickhoff and Riegl was not with the Greek classical but with early Medieval art. This different interest, which formed their starting point, provided both scholars with a new material of comparison, and as a result they began to revise drastically the then standard views on Roman art.

Their work is frankly polemical. It aims at a complete reevaluation of the Roman period. For Roman art exhibits not a decline but a development, if judged by its final outcome, the Christian art of the Byzantine period and the Middle Ages. Wickhoff in particular possessed a high sensitivity to the—nonnaturalistic—animation of premedieval painting. This enabled him, for instance, to "see" the Roman reliefs in the Arch of Titus as the forerunners of early Byzantine miniatures of the type of the *Vienna Genesis.*

Riegl's *Stilfragen* came first. He wrote them in order to demonstrate the continuous development of vegetable ornament from early antiquity to the Byzantine and Saracen arts. In this context a reevaluation of Roman art became inevitable. Riegl also saw the connection between the current low esteem of Roman art and the theory of a decline during the Roman period, which he questioned: "There was a process of evolution of ancient art during the empire, and its trend was rising, not declining, as everyone wants us to

believe."[32] Two years later Wickhoff expressly gave
his consent to this statement. His introduction to the
Vienna Genesis, soon afterwards translated and pub-
lished as a separate volume by Mrs. Strong, consti-
tutes the first modern book on Roman art.[33]

Wickhoff's book starts by discussing a particular
mode of representation common in Medieval art,
which shows the progress of an event by illustrating
the same person twice or more often at different mo-
ments but within the same composition. This he calls
"continuous" narration. He stresses the nonnaturalis-
tic character of such compositions, then proceeds to
show that the origin of this continuous style was in
Roman art.[34] In order to account for this phenomenon
so openly contradicting the naturalistic art theories of
his own time, he developed a new theory of Roman
art, which was to be of great consequence in the fu-
ture.

Wickhoff's own art theory is not really completely
divorced from the naturalistic. He understands art as a
process of representation rather than independent cre-
ation. Accordingly he stipulates a progress from "styl-
ized" to "naturalistic" representation in the sense of
objective naturalism (objects shown as they essentially
are). Then follows "illusionism." With this term he

32. A. Riegl. *Stilfragen,* p. 272. (Author's translation.)

33. F. Wickhoff, *Roman Art: Some of its Principles and their Appli-
cation to Early Christian Painting,* translated and edited by Mrs.
A. Strong (London and New York, 1900). All references in the fol-
lowing are to this edition. For the reference to Riegl, see op. cit.,
p. 17.

34. For later critical discussions of the continuous style, see
below, n. 54.

designates a representation of objects as they *appear* (not *are*), a kind of subjective naturalism. This is the highest form of art. Rembrandt and especially Velasquez are his favorite examples of illusionism.[35] The concept of decline is not entirely discarded by Wickhoff. Thus he arrives at the following reconstruction of ancient art. Greek art declines during the Hellenistic period. Meanwhile an illusionistic art has formed in Etruscan and Roman Italy (17 ff). Augustan art, still semi-Hellenistic, ranks relatively low in his esteem (26 ff). Its "imitative naturalism" is contrasted with the native, Etruscan-Latin trends. From the fusion of both the Augustan and the native grows the Flavian style, reaching its highest development with the reliefs on the Arch of Titus. The illusionistic Roman relief has thus been created—a kind of painting with sculptural shadows—and developed into a national style (48 ff; 73 ff). It gives rise to a new, Western and Roman art under Trajan with continuous compositions in the Column of Trajan (114). The same evolution can be observed in Pompeiian painting (117 ff).

A few years later Riegl published the *Spätrömische Kunstindustrie,* which also directly opposed itself to the ruling dogma of a decline in ancient art. In fact, he set out to apply a positive interpretation to those very "dark ages" which allegedly caused the disintegration of all arts. *Late Roman* to Riegl means the time between 313 (edict of Nicaea) and 768 (accession of Charlemagne), precisely the period which since the Renaissance had been generally denounced as the age of

35. For these terms, see F. Wickhoff, *Roman Art,* pp. 17 ff; pp. 117 ff.

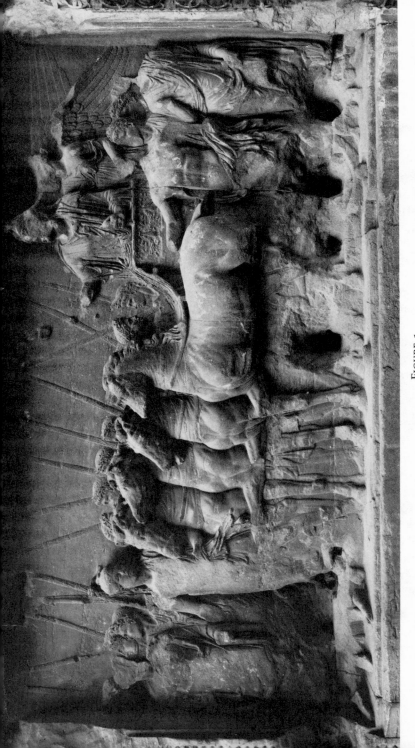

FIGURE 1

Relief representing the emperor in triumphal procession, from the Arch of Titus, ca. A.D. 80–90, Rome.

"barbarism."[36] For this purpose Riegl too gives a survey of Roman art under the Empire, concentrating more on the continuous stylistic trends than the division by periods. Like Wickhoff he aims to show how the late Roman style developed from the earlier, but he places greater emphasis on the continuity of art during the critical centuries after Trajan. It is equally important to see how this book supplements and confirms and how it criticizes the theory of Wickhoff.

The concepts of Riegl are in general more analytic-philosophical, less pragmatic-impressionistic. Foremost amongst them is the concept of *Kunstwollen*. The literal translation, "artistic intention," does not sufficiently cover the meaning which Riegl implied with this term. "Stylistic intent" might be more adequate. The word and the concept were inspired by another polemical concern of its author. It is directed against the materialistic theory which holds that forms in art result automatically, as it were, from techniques, materials used, or other physical conditions. To these ideas Riegl opposes the Kunstwollen as a formative will, which in all techniques and materials achieves its own end, a specific style. As far as styles of art are common to entire periods, it follows that a common, perhaps fundamentally instinctive, Kunstwollen must be assumed in all individuals of a period. This collective factor or common formative intention determines the taste and dominant interests of art at any one time. It is the origin of the periodically changing and no less

36. *Kunstindustrie*, 10; opposition to earlier theories, 4. Among his predecessors in the reevaluation of Roman art Riegl gave recognition to Jacob Burckhardt, op. cit., p. 3. Wickhoff referred to H. Brunn, *Roman Art*, p. 54 n.

collective styles of art. As a common denominator it connects all artistic productions of an age, even the forms of architecture, with the coeval sculpture, painting, and minor arts—the *Kunstindustrie* to whose study the book was dedicated in the first place.[37]

Riegl, unlike Wickhoff, does not ascribe true illusionism to Roman art. In the *Kunstindustrie* the entire history of art is viewed as a history of spatial representation (51 ff.), and Riegl holds that the illusion of space was not within the intention of Roman artists. The Kunstwollen of all ancient art including the Roman Empire is concerned with "isolation of individual forms in the plane," not the connection of forms by a common spatial medium, as in Renaissance art (45). Thus Riegl revises the findings of Wickhoff regarding the spatial effect of certain Roman reliefs. There is a continuous development, however. Classical Greek reliefs show the forms connected with the neutral ground from which they seem to grow and which is a "tactile ground," that is, a real part of the sculptural form. During the Roman era this relation between ground and objects changes gradually. Late Roman reliefs place the figures in front of the ground, which has lost its sculptural function, because the forms are detached from it. Instead they relate to an imaginary foreground-field, the "optical plane."[38] The real ground only appears in the dark intervals between sharply outlined forms; it has become a negativism. Thus the space theory of Riegl affirms a continuous progress far beyond the imputed illusionism of the first century A.D. Not before the time of Constantine

37. *Kunstindustrie*, pp. 5 f.
38. Op. cit., pp. 7 f; 47.

have the Roman reliefs achieved a complete and resolute detachment from the tactile ground. Then only the way was free for the Medieval and newer arts to develop. In the reliefs, painting, and mosaics after Constantine the change becomes obvious. Figures and objects are now seen in the optical foreground-plane; for the first time in history the artists show them in front of—not in contact with—a ground which has become background, suggesting space. Roman art of the Empire constituted the inevitable transition between these two modes of "seeing," the classical and the postclassical.

One should read the *Kunstindustrie* after the *Wiener Genesis*. The original inspiration and visual sensitivity was Wickhoff's. Much in Riegl's book is best understood as a critical restatement of observations by Wickhoff. This is especially true of the descriptions of reliefs, the methodical investigation of the visual elements, space, light, and shadow, in ancient art, the distinction of three stages in this evolution. Riegl, too, included Egyptian art in his investigation, in order to exemplify the first stage of his evolutionary scheme, described as wholly tactile without regard to optical illusion, and this corresponds with Wickhoff's general description of prenaturalistic art as "stylized." It is true that Riegl needed a new terminology of stylistic description, for the reason that, unlike Wickhoff, he wanted to describe the entire trend of art in each period, including the nonrepresentational arts like architecture. Nevertheless the thorough rewording of all the stylistic concepts which he accepted from Wickhoff indicates a more fundamental difference of temperament. Riegl objectified the system outlined by Wick-

hoff. Where the latter related impressions and experience, Riegl stated reasons and explained. The esthetic sensibility of Wickhoff was impressionist, pre-Cézanne, that of Riegl analytic, on a level with Cézanne. Riegl could conceive of a change of art, even beyond the ideal of *Schönlebendigkeit* as which he summarized the contemporary program, "beauty" understood as proportioned form, "animation" as natural motion. Therefore he was better equipped than Wickhoff to account for the fact that the Romans did not abide by the similarly balanced vivacity of the Flavian and Trajanic reliefs. He was able to regard the "crystallized" forms and "disproportion" of Constantinian art with interest, as important symptoms of change but not necessarily of decay. Riegl was mistaken in ascribing to the late Roman artists a theory of pure vision not unlike that of Cézanne.[39] Nevertheless his claim does not seem unjustified that he was the first to close the gap, left open by the Renaissance theorists, of a dark age between ancient and modern

39. The underlying assumption with Riegl no less than Wickhoff was that artists at all times represent what they see; the changes of style therefore seemed to depend on optical theories. A materialistic concept of art, common during the nineteenth century, is reflected in these ideas. Reasons why the scientific terminology of Riegl proved inadequate to late Roman art have been given by G. v. Kaschnitz-Weinberg, *Gnomon* 5 (1929), pp. 195 ff. Riegl was not wrong, however, in assuming that a theory of pure vision can lead—in fact, must lead—to an abstract art; see his remarks in *Kunstindustrie*, pp. 64 f. Modern art, which was actually based on such a theory, bears out Riegl. The early cubists still painted what they "saw," as one learns from Picasso's conversations with Miss G. Stein.

art. After his demonstration the late Roman period was no longer a vacuum.

In its most general aspect the reevaluation of Roman art by Wickhoff and Riegl implies a positive interpretation of modernism. The negation of a decline in Roman and late classical art has an optimistic slant toward the future. Correspondingly, on the other hand, the emphasis on the decline and downfall of ancient civilization often carries a retrospective and nostalgic connotation; sometimes it is charged with the emotional overtones of resignation or guilt.[40] Yet both philosophies are apt to refer to the Roman problem as a test case for any theory of cultural change, regardless of whether these changes are interpreted as biological cycles, like growth and decay, or as continuous evolution. In scrutinizing the past fate of Rome the modern world has more than once felt that a problem of the present also was at stake.

Wickhoff and Riegl agreed on the positive interpretation of the Roman phenomenon. In other, hardly less important respects their historical views differed. As we have seen, a systematic thought of considerable scope was implied in Wickhoff's conception of Roman art. Varying modes of artistic representation express various attitudes toward reality. The word *illusionism* was coined in order to characterize an art that deals with sensuous images, not the intrinsic forms of the world around us. Wickhoff made the point but did not especially stress it; Riegl neglected it, or perhaps took

40. Cf. the interesting remarks of Fustel de Coulange, apropos of Couture's well-known painting *The Romans of the Decadence*, J. J. Seznec, *GBA* 24 (1943) : 221 ff.

it for granted. This must be regretted, for in the subsequent discussion on Roman art the systematic meaning of Wickhoff's terms was rarely realized. *Illusionism* was commonly understood in a less precise sense, as a kind of impressionistic technique, a sketchy though colorful method of representation.

Riegl, on the contrary, was inclined to stress the systematic nature of his concepts. The progress from tactile to optical representations to him had the binding force of a natural law. Therefore he diagnosed correctly the late Roman concern with space but failed to explain other equally obvious characteristics of late Roman art, like the return to a new concept of essential form.[41] Wickhoff saw the interaction of various trends in Roman art more realistically, because he did not presuppose the cultural uniformity of a historical period. In regard to this question the closing chapter of the *Kunstindustrie* is especially interesting. There, in a brief epilogue, Riegl set out to demonstrate the validity of his concept Kunstwollen beyond the limits of art proper (215 ff). So defined, the concept no longer denotes a formative will of art only, but a basic regulative principle underlying all cultural expressions of an age. It might be more correctly called a *Kulturwollen*. No doubt we deal here with a heuristic principle of the first order, whose consequences reach far beyond the field of art criticism into the theories of history, anthropology, and sociology. On the other hand Riegl's thought in this instance foreshadows the deterministic theories of cultural integration which made their appearance in the twentieth century from

41. Cf. G. v. Kaschnitz-Weinberg, op. cit. (above, n. 39), pp. 201 f.

Spengler to Toynbee. And here a serious dilemma announces itself. In all theories which impose a totalitarian uniformity on the historical-cultural periods, as in the abstractions "Gothic man," "Baroque spirit," etc., art once more appears to be a mere function of circumstances. Yet Riegl's term demands a degree of freedom for the arts to express a deliberate choice. It loses all meaning when no choice is left to the artist to exercise a "formative will." While the idea of a collective Kunstwollen in a totally integrated culture may prove a ready means for the historian to illustrate his point, it is hardly a suitable instrument for the investigation of works of art. The danger is, if the concept is so used, that the historian takes for granted what he has set himself to investigate; he reaches a foregone conclusion.

One other point must yet be mentioned regarding the definition of the term *Roman*. Riegl's view of the Roman achievement in art remained universalistic. In the continuous, universal process of history *Rome* signifies a period, the transition from the ancient to the new condition of the western world. From his viewpoint, no distinction between Greek and Roman art seemed indicated except in terms of chronology; in this respect he was no less universalistic than Winckelmann.[42] Wickhoff, on the other hand, took up a different position. He felt that a sharp distinction should be made between Roman art with its native Italic background and Greek. To him the art of Rome was a national phenomenon.

42. Cf. the passage quoted above, n. 1, from *Kunstindustrie*, 10; Riegl's criticism of Wickhoff, regarding the assumption of a national Roman style, op. cit., pp. 6; 63 f.

Orient or Rome

Around 1900 the discussion of Roman art entered upon a new phase which is easily recognized, if only by the rapidly increasing host of publications on the subject. The outstanding fact is that Roman art had become an object of attention and a field of study in its own right. For this change the books of Wickhoff and Riegl were not the sole reason. They appeared at a propitious moment, however, and in the ensuing reviews and discussions important additions and corrections were brought forward almost at once. A surprising and, it may seem today, somewhat inexplicable vehemence is sometimes shown in these controversies. The point is worth noting as another characteristic of the new situation, which recalls the equally violent reaction to contemporaneous modernism in literature and painting.

At the same time, and often quite independently of these theoretical discussions, the archaeological contributions to Roman art increase in number. The effect of the great publications of monuments begins to be felt: H. Brunn's publication of Etruscan urns, since 1870; C. Robert's *Die antiken Sarkophagreliefs*, since 1890.[43] The outline of a documented history of Roman portraiture can be gleaned from the volumes of J. J.

43. H. von Brunn, *I rilievi delle urne etrusche* (pub. a nome dell'Istituto di corrispondenza archeologica, Rome 1870–96); C. Robert, *Die antiken Sarkophagreliefs* (Archaeologisches Institut des deutschen Reiches, Berlin, 1890–1939). Both works are not yet completed; publication continues.

Bernoulli's *Roman Iconography*, even today not fully replaceable,[44] and in the new, scholarly catalogues, like Amelung's *Sculptures of the Vatican*, Greek and Roman objects are treated with equal justice.[45] The partial recovery of the Ara Pacis Augustae, since 1871,[46] and A. Mau's investigations of Pompeiian painting,[47] were already utilized by Wickhoff and Riegl. In 1900, coincident with Riegl's *Kunstindustrie*, A. Furtwängler's work on the engraved stones appeared. This included an admirable survey—the first based on original materials—of the conditions of art in Italy from the archaic to the Augustan period.[48] In

44. J. J. Bernoulli, *Römische Ikonographie*, 4 vols. (Stuttgart, 1882–94).

45. W. Amelung, *Die Sculpturen des Vatikanischen Museums* (im Auftrage und unter Mitwirkung des kaiserlich deutschen archaeologischen Instituts, Römische Abteilung), 4 vols. (text and plates) (Berlin, 1903–8); publication continued by G. Lippold. This work was preceded by earlier catalogues of similar scope, but published without plates, like O. Benndorf and R. Schöne, *Die antiken Bildwerke des Lateranensischen Museums* (Leipzig, 1867); F. Matz and F. von Duhn, *Antike Bildwerke in Rom, mit Ausschluss der grösseren Sammlungen*, 3 vols. (Leipzig, 1881–82). The sculpture catalogue of the British Museum appeared about the same time: A. H. Smith, *A Catalogue of Sculpture in the Department of Greek and Roman Antiquities, Brit. Mus.*, 3 vols. (London, 1892–1904). Publication continues.

46. F. v. Duhn, "Sopra alcuni bassorilievi che ornavano un monumento pubblico Romano dell'epoca di Augusto", *AnnIst* 53 (1881) : 302 ff.; cf. 302 n. 1. E. Petersen, *Ara Pacis Augustae* (Vienna, 1902), pp. 8 f. See also below, p. 60.

47. A. Mau, *Geschichte d. decorativen Wandmalerei in Pompeji* (Berlin, 1882).

48. A. Furtwängler, *Die antiken Gemmen; Geschichte der Steinschneide–Kunst im klassischen Altertum*, 3 vols. (Leipzig and Berlin, 1900).

1907, Mrs. A. Strong, the translator of Wickhoff, published her own book on Roman art, which, with its subsequent editions and supported by her many other publications, has remained the standard textbook in the field.[49] It is understandable that in the introduction, which still makes interesting reading, Mrs. Strong referred to the impressive record of these recent studies as a "Roman movement" and a veritable "revival."[50]

This interest in Roman art lasted once it was aroused; it survived wars and revolutions. At first sight its result may seem a multitude of useful and necessary research but no outstanding change of principle. Yet in reality the theories of Wickhoff and Riegl are no longer ours. A change has occurred. The early twentieth century, no less than its predecessors, created its own theory of Roman art. This time the change came about more gradually. It was not so openly proclaimed nor was it epitomized in a single book or article.

The new situation can be summarized as follows: Roman art, at this stage, has many more advocates

49. E. Strong, *Roman Sculpture from Augustus to Constantine* (London, 1907). The book was later rewritten and published in Italian: *La scultura romana da Augusto a Costantino*, traduzione italiana di G. Gianelli dall'opera intieramente rifatta dall'autrice, 2 vols. (Florence, 1923–26). Comprehensive works on Roman art by the same author: *Art in Ancient Rome*, 2 vols. (London, 1929); *Apotheosis and Afterlife; three lectures on certain phases of art and religion in the Roman Empire* (London, 1915), pp. 2 ff. (introductory address); "The Art of the Roman Republic," *Cambridge Ancient History*, vol. 9 (Cambridge, 1932), pp. 803 ff.; "The Art of the Augustan Age," op. cit., vol. 10 (Cambridge, 1934), pp. 545 ff.; *Encyclopedia Britannica*, s.v. "Roman Art."

50. E. Strong, *Roman Sculpture*, p. 24.

than before; one finds a greater readiness to accept its esthetic standards. However, most writers on the subject still feel apologetic. As Mrs. Strong put it in 1915: "The art of the Roman Empire is no longer dismissed as a last unimportant chapter in the history of the decadent antique; the endeavor is now to prove that this art was not Roman at all."[51] We add: the endeavor of its defenders, on the other hand, now is to prove that this art *was* Roman.

One recognizes the difference. The controversy from Winckelmann to Riegl centered on the esthetic evaluation of Roman art. Now the terminological question moves into the foreground. What is meant by Roman? This, for the time being, emerges as the most hotly debated aspect of the Roman problem. How, without a plausible solution of the terminological problem, can anyone hope to answer the question, what is Roman about Roman art?

Winckelmann had declared that Roman art was the decadence of the Hellenistic style. In 1901, opposing Wickhoff, J. Strzygowski made virtually the same assertion and thereby set off the long and acrimonious argument to which Mrs. Strong particularly alluded in her above-quoted sentence. Yet Strzygowski did not deny the "rising line" in the late and postclassical development. He merely denied that the rising trend was either Greek-Byzantine or Greek-Hellenistic or, least of all, Roman. Instead he identified it with an assumed reactivation of the old culture regions along the northeastern, eastern, and southern borders of the empire. Strzygowski located the original source of energy from which these far-reaching changes issued in the

51. *Apotheosis and Afterlife*, p. 3.

mysterious heartland of Asia, in Iran. This is the meaning of his programmatic title, *Orient or Rome*: what appears new, or Roman, in Roman and early Christian art was really the gift of the Orient to Rome—"Orient" being taken in a rather sweeping sense, comprising both the native and Hellenistic cultures of Asia Minor, Syria, and Egypt.[52]

In one respect this modern theory implied a very drastic change of values. The decline of Rome is taken for granted, as is that of all Hellenism. But it is not ascribed here to the much decried influx of orientals. On the contrary, the cultural contribution of the East receives a decidedly positive evaluation:

> In Syria, Alexandria and Asia Minor . . . probably originated the creative urge, not yet exhausted, which induces the architect to conceive the formation of space more than the articulation of mass. Two architectural types take the place of the old: one whose outstanding feature is the dome, as the perfect expression of a composition centering on interior space; the other type, the basilica, that *pasticcio* of spatial and mass architecture to which only the Germanic people (die Germanen) in their Gothic cathedrals could impart unity of space by overcoming victoriously the resistance of the weighty mass.[53]

This sentence is fraught with arguable ideas and judgments, and obviously is not an impartial statement. But what especially interests us here is its outspoken

52. J. Strzygowski, *Orient oder Rom; Beiträge zur Geschichte der spätantiken und frühchristlichen Kunst* (Leipzig, 1901). For a brief and comprehensive evaluation of Strzygowski's work, see the obituary by E. F. Herzfeld, W. R. W. Koehler, and C. R. Morey, in *Speculum* 17 (1942), pp. 460 ff.

53. Op. cit., p. 10 (author's translation).

partiality for the East and the North against Latinism and Hellenism, the very reversal of the old theory that the arts declined under the barbarians.

The introduction to *Orient oder Rom*, from which the above quotation stems, was written as a critique of the *Wiener Genesis*. In it the chief weaknesses of Wickhoff's book are clearly and not unjustly pointed out. It is doubtful if the method of composition called "continuous" by Wickhoff can be claimed as a Roman peculiarity,[54] and it is quite certain that illusionism was a Hellenistic and not originally a Roman trend, if by this term we understand no more than an *illusionistische Malweise*.[55] Yet, as we saw, Wickhoff also implied with his term a more systematic meaning, introducing it as the third stage of a general evolution of art. This aspect was entirely disregarded by Strzygowski as by most other contemporaries, Riegl included. Moreover, Riegl's own scheme of the universal development of art by way of three modes of vision found equally little interest even with those readers who accepted his pleading of the special case, the progress of Roman art. One can hardly avoid the conclusion that for the time being the interest in the problem of national arts had eclipsed the search for a universal principle of evolution.

Wickhoff himself prepared the way for an interpretation of Roman art as a native "Italic," i.e., a national, manifestation. Now Strzygowski opposed him, not because he saw art and culture in a continuous

54. Op. cit., pp. 3 f. For the concept of "continuous" narration in art, cf. also above, p. 26, and the more recent discussions of Roman "historical" reliefs cited below, nn. 105, 106.

55. Strzygowski, op. cit., pp. 6 f.

process of evolution like Riegl, but rather as the dis-
coverer of other national and racial energies, those of
the Orient and the North, not yet sufficiently appreci-
ated. In his vehement defense of the supremacy of
Asia in and beyond the Byzantine civilization Rome
was to him but of passing interest. He judges the Hel-
lenistic-Roman world of the Empire "a colourless
mass-culture," incapable of creating an "individual
culture" and a "national art."[56] We sense the new
creed that all art must be the expression of a national
spirit.

The complicating factor in these discussions is a cer-
tain radicalism of principle often incongruent with the
conditions of ancient art. Modern nationalism arose
from conditions of the eighteenth and nineteenth cen-
turies to become what it now is, the strongest public
sentiment of our times. It seems unlikely from the out-
set that any product of ancient or medieval civiliza-
tions should be found in complete agreement with an
idea so modern. Indeed it is difficult to construe
Roman art as a national art in this sense. Strzygowski
has pointed out some of the reasons: the lack of
famous artists with Roman names, the difficulty of
claiming as specifically Roman such characteristics as
the illusionistic technique of painting.[57] These are
valid observations. But because of them to deny the
problem itself and return to the opinion in force be-
fore Wickhoff, that Roman imperial was only the last
phase of Hellenistic art, must seem a step backwards.

56. Op. cit., p. 8.
57. Op. cit., p. 8. Cf. 5, "The main point is that representation
by means of light and color is not a national talent, but may occur
with all peoples who have a gift for art . . ." (author's translation).

Such an attitude failed to live up to the reality at hand, the monuments. It was no better than to declare, for instance, that all is said about Baroque art, if instead of Baroque we call it the latest phase of the Renaissance. Undoubtedly Baroque painting grew from that of the Renaissance, but in art results count for more than origin, and so "Baroque" is different from "Renaissance." Likewise, to use a standard example of first-century art, the reliefs in the Arch of Titus undoubtedly incorporate a great deal of Hellenistic experience and at least one oriental element in the monarchic interpretation of the triumphator. But the result, again, is something apart from all truly Hellenistic and Oriental art. Here, as in anything that we judge by its form, the aggregate is more than a mere sum of the contributing factors. It is something in its own right, which we may call Roman.

With respect to critical method, the following points should be noted. The discussion of Roman art has now completely abandoned the historical universalism of Wickhoff and especially of Riegl, which in the great changes of style demonstrated the underlying general law of evolution. Instead, we find evidence of a new historical realism. The argument about the relation between Rome and the Orient turns on the interaction of historically identifiable forces rather than a logical and general principle of evolution.

Although this controversy lies for the most part beyond the scope of this essay, it concerns the study of Roman art before Constantine in one respect. It emphasizes the Hellenistic factor and beyond that the action of essentially non-European, "Oriental" elements in the Roman Empire. While the extent as well

as the esthetic and cultural evaluation of this Oriental contribution remained an arguable matter, the cultural supremacy of Rome during the "Roman" era was once more put in doubt.[58] The conclusion was at once drawn by Strzygowski that the history of Roman imperial art might be more adequately described as the simultaneous development of several artistic centers rather than of Rome alone.[59] The suggestion was not carried out immediately but was recently adopted for one of the latest synoptic presentations of Roman art, by C. R. Morey.[60]

58. See E. Strong, *Roman Sculpture*, pp. 12 ff. Cf. the interesting chapter on "Rome et l'Orient" in F. Cumont, *Les religions orientales dans le paganisme romain*, (Paris, 1929), pp. 1 ff. The various contributions of the East to Roman civilization, enumerated in this chapter, may be conveniently divided into three categories: (*a*) Roman adaptations (e.g., of Ptolemaic methods of government to the imperial administration); (*b*) contributions of individuals (e.g., of Ulpian of Tyre and Papinian of Emesa to Roman law, or of Apollodorus of Damascus to Roman architecture); (*c*) collective contributions of the native, eastern Hellenistic peoples (especially in the field of religion). Therefore "Rome" and "Orient" were not real opposites during the first two centuries A.D. The trend towards a pan–Mediterranean civilization started in the Hellenistic era and continued under Roman rule. Assimilation was mostly voluntary, not enforced; regional tendencies persisted but did not often consciously oppose the "world" standards. For this state of affairs see M. Rostovtzeff, *A History of the Ancient World*, II (Oxford, 1927), pp. 286 ff.; idem, *Social and Economic History of the Hellenistic World*, II (Oxford, 1941), pp. 1309 ff. A brief list of corrections according to recent research of Strzygowski's findings in *Orient oder Rom* is found in G. A. S. Snijder, "Het Probleem der Romeinsche Kunst," *Tijdschrift voor Geschiedenis* (1934), pp. 6 ff. Cf. above, n. 52.

59. J. Strzygowski, *Orient oder Rom*, pp. 9 f.

60. See below, pp. 81–83, and n. 99.

Otherwise the Orient or Rome controversy had little immediate influence on the studies of Roman art. It failed to open new avenues of understanding where they were most needed, with regard to the monuments of Italy and especially Rome herself. The strict denial of a Roman art after Wickhoff and Riegl ran counter to common experience. Indirectly, however, it undoubtedly strengthened the existing trend. The search for the proper characteristics of Roman art was felt to be the pressing task after 1901 even more than before.

The Age of Nationalism

Nothing, perhaps, illustrates more clearly the success of Wickhoff and Riegl than the fact that the continued efforts to define the specific quality of Roman art were so persistently concentrated on representations in relief and the problem of space. The two pioneers of Roman art themselves had not overlooked the other outstanding group of Roman monuments, the portraits. Wickhoff derived from them his famous distinction between the "typical" Greek and the "individual" Italic style. Riegl not only included portraits in his demonstration of the progressing "crystallization" and "distant-optical" effects of Roman art; he also recognized their firm gaze as a characteristic attitude indicating an awareness of the spatial world into which these works seem to look.[61] But such observations,

61. *Kunstindustrie,* p. 70. The function of the eye is different in Greek portraits; see L. Curtius, "Geist der römischen Kunst," *Die Antike* 5 (1929), pp. 190 f.

however important, were nevertheless subordinated to the prevailing interest in the development of "illusion" or "optical" intention in Roman reliefs. They did not in themselves constitute a theory of portrait art comparable to the new theory of space in art. The need for a more exclusive and concentrated study of Roman portraits was soon afterwards stated in a brief study by A. Wace.[62] Mrs. Strong in her own book on Roman sculpture again dealt almost exclusively with the reliefs, but added a special chapter on portraiture from Augustus to Constantine. Portraits were thus accepted into the first modern handbook on Roman art but not integrated with the historical survey by periods which constituted the main body of the text.[63]

This persistent emphasis on one aspect of Roman art may surprise us, because the recent controversies had already indicated that the spatial illusionism of these monuments might not be so specifically Roman as Wickhoff thought. Therefore the reliefs would seem to offer a less promising material than, for instance, the portraits, if one wished to define the proper characteristics of Roman art. Yet, to discover an inner coherence, i.e., an inherent Romanitas, in all Roman works was the more or less outspoken purpose of the new Roman studies. Thus, Mrs. Strong in her much quoted book set out to describe "the solidarity of artistic endeavour" in Roman art.[64] That in these circumstances the reliefs nevertheless continued to hold the center of interest was primarily due to Wickhoff's influence.

62. A. B. Wace, *Evolution of Art in Roman Portraiture* (Rome, 1905).
63. *Roman Sculpture*, pp. 347 ff.
64. Op. cit., preface, viii.

There was, however, an additional reason, namely the actual, political content of the so-called historical reliefs, which began to be recognized more often as a distinctive feature of Roman art.

Without an insight into this broader background of ideas, the following discussions of Roman art can hardly be understood. As we said previously, signs of another ideological change appeared around 1900 in the criticism of Roman monuments. The new ideas matured slowly, and culminated after the First World War in two studies almost simultaneously published in Munich by J. Sieveking and C. Weickert.[65]

The essay by J. Sieveking, according to the summary, was written in order to correct Wickhoff in a fundamental point. It argues the superior importance of Augustan art.[66] In the evolutionary scheme of Wickhoff the Flavian style held the place of honor with good reason. It marks the height of that illusionism toward which all development was directed and which, according to Wickhoff, was the essential content of Roman art. It is evident that, by shifting the emphasis from the Flavian to the earlier Augustan style, Sieveking stipulated a different development and a different content of Roman art.

Important, in principle, is the fact that Sieveking no longer uses illusionism as a capital term.[67] Instead, the

65. J. Sieveking, "Das römische Relief," in *Festschrift P. Arndt* (Munich, 1925), pp. 14 ff.; C. Weickert, "Gladiatoren–Relief der Münchner Glyptothek," *MJ* 2 (1925) : 1 ff.

66. Sieveking, op. cit., p. 35.

67. *Illusionistisch* still occurs on occasion as a general attribute of Roman reliefs. It refers to the "illusion of spatial effects" as well as the calculated effects of light and shade, much as in Wickhoff; see

essential content of Roman art as exemplified by the reliefs of the Ara Pacis Augustae consists of three "specifically Roman" factors: 1. "effect of spatial depth;" this tendency developed in Italic reliefs (e.g., Etruscan urns) as opposed to Greek-Hellenistic art. 2. A modified Greek element, the "neo-Attic" (e.g., in the representation of draperies). 3. A "sense of reality," which expresses itself in two ways, in the representation of actual (political) themes, not shown in Greek art, and in the naturalistic rendition of details.[68]

In accordance with this interpretation Wickhoff's evolutional scheme also had to be changed. In fact the history of the Roman reliefs no longer presents itself as a continuous evolution; there is no logical principle or recognizable aim of development. Instead, two principles, one Greek, the other Roman, stand in opposition to each other, and their varying states of prevalence or decline in relation to each other determine the periods of Roman art. That is to say, the rational idea of evolution has now entirely given way to a more pragmatic concept, the irrational succession of events. According to Sieveking's outline, the Roman idea of art was first realized under Augustus. Space, its native theme, continued to develop through the Claudian and Flavian periods (28). A regression started during the reign of Trajan; under Hadrian we witness a complete "break with the Italic, spatial idea of representation" (29). However, in the new space representations which appear at the time of Marcus

the discussion of the reliefs in the Arch of Titus, Sieveking, op. cit., p. 27. But no systematic significance like the one discussed above, pp. 28–29, is now implicit in this word.

68. Sieveking, op. cit., p. 22.

FIGURE 2
Relief representing the imperial family in procession, from the
Ara Pacis Augustae, 13–9 B.C., Rome.

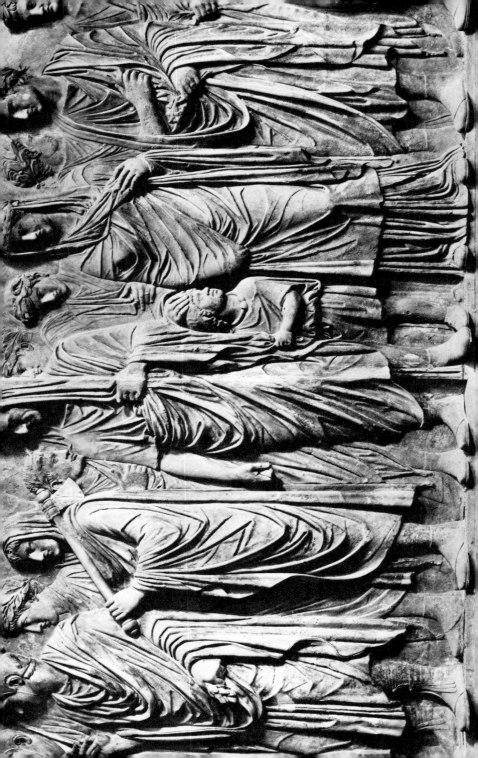

Aurelius the Italic tradition was revived (33 ff.). After the year 250 a regression set in again and this time proved final. Late classical reliefs are flat, striving for "ornamental, black and white effects" (34). In a presentation which evaluates spatial effects so highly this verdict on late classical art can only mean a decline. The decline is specified, however; it is the Roman component which has declined, or succumbed, to other trends, Greek or Oriental.[69]

The article by C. Weickert has a more limited scope. Its subject is a fragmentary Roman relief in Munich representing with considerable realism the closing episode of a gladiatorial game. Because Weickert assigned this monument to a date between 110 and 80 B.C.,[70] his detailed investigation carries the discussion on Roman art beyond the Augustan into the end of the Republican period. The article is of importance principally as a supplement to the simultaneous essay by Sieveking.

In the introduction the brief survey of earlier studies on Roman art is interesting because of the definition given of the late classical style. Unlike Sieveking, but also Riegl whose positive evaluation of this style he otherwise shares, Weickert finds the explanation of late classical art precisely in the weakening of the Greek influence; thereby "the genuine Roman element emerges more clearly" (2). The possibility of an even more comprehensive reconstruction of Roman art as

69. Op. cit., p. 34. An oriental component of Hellenistic art is assumed to emerge in the Pergamene Telephos frieze, op. cit., p. 19.
70. "Gladiatoren–Relief," p. 37.

FIGURE 3
Roman relief representing gladiatorial games, Munich. (Staatliche Anti-kensammlungen und Glyptothek)

the rise of an original, Italic style gradually freeing it-
self from foreign influences thus appears. But one also
notices the highly theoretical presuppositions of such
a theory. It depends not only on our positive esthetic
evaluation of the late Roman production, but also on
the conviction that there is a constant, native compo-
nent in Roman art, whose characteristics remain rec-
ognizable or even "emerge more clearly" to the end of
antiquity. A characteristic of such fundamental nature
Weickert, like Sieveking, declares to be the represen-
tation of space. Accordingly, he too maintains that
Greek reliefs do not show space, while in Rome in
spite of strong Greek influences during the Augustan
age the Italic tradition continues to represent space,
"which is foreign to Greek art." [71] Both authors further
disagree in one other detail which is not without sig-
nificance. Weickert does not admit that the quality of
space is also present in the Etruscan reliefs; he con-
siders it purely Italic-Roman, not due to any foreign
(Etruscan) influence (26 ff.).

There can be little doubt that we have to do here
with a new theory of Roman art. This approach is en-
tirely based on the novel concept of the national char-
acter of art, a concept which has acquired general sig-
nificance only in our time. It is now taken for granted
that the groups which we call nations produce the
styles of art, and that they have this effect not only
sometimes or in certain cases, but always and by ne-
cessity. Just as most nations possess a language of
their own, have a literature and cultural tradition of

71. Literally (the "Italic" tradition continues) "in Gestalt der
dem griechischen fremden Raumeinbeziehung," Sieveking, op.
cit., p. 35.

their own, and in the course of history have aspired to autonomous statehood, so, it is assumed, a definite style of art is proper to each of them owing to national traits of character. Consequently we are confronted with a modern, nationalistic principle of criticism which operates in two ways. By this principle differences of style can be interpreted as expressions of national diversity, or, vice versa, differences of nationality can be expected to express themselves in an analogous diversity of artistic styles. The more the nationalistic idea develops, the more it tends, as a matter of principle, to stipulate an autonomous art for every nationality, just as political theory demands an autonomous state for every nation.

These notions are sufficiently well known for us to dispense with their further description. They have long been in the making, but during the nineteenth century their theoretical foundation underwent considerable change. In discussing the Greek character Winckelmann was still content with the Aristotelian explanation that ethnical differences result from different climates. Modern nationalism is not so easily satisfied. Too many and diverse events have occurred under the same mild Mediterranean sky to admit of so simple an explanation. The ancient civilizations have vanished without a change of climate; other cultures have arisen in the same climate and proved different. Therefore nationalistic theory looks for other factors, especially the presumed homogeneity of aboriginal, linguistic, or racial groups, in order to explain the unity and coherence of the historical civilizations. In this interpretation of the past modern humanity pays homage to its own overwhelming experience of the

appalling energies of creation and destruction which have accumulated in our great national states.

It must be pointed out, however, that if we apply this modern nationalistic interpretation to Roman art we make assumptions, the same assumptions which we make when we explain French or English or any other national art as the manifestation of an ever present, national spirit. We assume in particular that certain Roman characteristics remain constant in all Roman works and in all vicissitudes of time, because these qualities correspond to certain native and equally constant propensities of the Romans as a group, a nation, or a race. From there it is only one step to the further assumption that the entire history of Roman art, in the last analysis, is only the evolution of a single inherent principle from its primitive or prehistoric origin to its final disintegration. This, indeed, is the final consequence of any nationalistic theory of culture or art.

Riegl's own concept, the collective "formative will," is still active in these speculations. But the difference between his thought and the new theory is equally apparent. In the universalistic scheme of Riegl, Kunstwollen has an epochal meaning; it expresses the spirit of a historical period. To use a term of Hegel, it is the function of a zeitgeist. In the nationalistic theories art appears to depend on no less suprapersonal forces, but the source from which the formative will flows is differently conceived. It more clearly corresponds to the romantic idea of a *génie national* (*Volksgeist*), or national genius.[72]

72. Zeitgeist obviously is a historian's idea, and as such it is of Roman coinage. J. M. C. Toynbee pointed out that Tacitus called

Both concepts have in common that they lend them-
selves easily to a deterministic interpretation. In the
critical and historical analysis of art this trend tends to
ignore the spontaneous aspects of the creative process.
Its methodical justification is the fact that large groups
of anonymous works such as the Roman reliefs must
first of all be described by their typical, not individual
qualities. They cannot be studied or methodically ar-
ranged except in typological categories. Peculiar to the
new critical attitude is not this method but the readi-
ness to generalize and to take typical qualities of style
as evidence of a national character.

Theories of this kind presuppose a complete domi-
nation of the impersonal style—expression of national
character—over the personal will of the artists. As
Weickert puts it apropos of the Hadrianic classicism,
which temporarily deserted the allegedly national,
Roman principle of space, "naturally the disregard of
space is carried only so far as this is at all possible in
Roman works" (39). Such statements rate the artists'
freedom of choice rather low. On the other hand they
leave open the question of what really enforces this

the "spirit of the times" the *saeculum; The Hadrianic School* (Cam-
bridge, 1934), 239. One may add that after the time of Hadrian the
saeculum personified, in the form of a Genius Saeculi, actually ap-
pears in the representations of art; see the silver platter from Para-
biago, as explained by this writer, *AA* (1935), 522 ff. To translate
volksgeist into Latin may prove more difficult. It seems a modern
idea. There is of course a Genius populi Romani, but this per-
sonification hardly embodies the same meaning as the modern
French eighteenth-century concept of génie national. A. Grenier
used the latter concept in his book, *Le génie romain dans la religion,
la pensée et l'art* (Paris, 1925); see the explanation given by his edi-
tor, H. Berr, op. cit., p. vi, n. 1. See below, n. 91.

adherence of the artists to the impersonal styles. Is the reason a rational condition, e.g., the training in workshops, or an irrational, instinctive disposition? Generally this trend favors the latter alternative. One begins to feel the methodological influence of prehistoric research, in which changes of style are now commonly accepted as evidence of ethnical changes.[73] In a similar sense these discussions of Roman monuments presume a basic, national principle of style; exceptions from this principle appear as something foreign or un-Roman. The new theory could but intensify the search for a single and unifying, stylistic principle in Roman art. It demanded a radical distinction between Roman and Hellenistic elements, and it evaluated highly those symptoms which in historical Roman art could be claimed as native (*bodenständig*, "homegrown") to the Roman or Italian territories.[74] That the constituent principle of any national art must be a native quality of local artists and not due to foreign influences was now considered a requirement a priori. In the aboriginal purity of its distinctive stylistic intent rests

73. A representative statement of this principle is found in F. Matz, "Das Kunstgewerbe Alt–Italiens," (E. Bossert, *Geschichte d. Kunstgewerbes aller Zeiten und Völker*, 1) (Berlin, 1928), p. 202. Style in art is the exponent of either a personal or a national-psychological (*völkerpsychologischen*) disposition. "Therefore as a rule the migration of a stylistic peculiarity (*Stilphänomen*) in this sense depends, as on its condition, on the migration of an integrated national body (*geschlossenen Volkskörpers*) and vice versa." (Author's translation.)

74. Sieveking, op. cit., p. 35, concerning Augustan art, which includes "a native Italic stratum" (*bodenständige italische Schicht*) of spatial representation; see Weickert, "Gladiatoren–Relief," p. 38.

that spiritual autonomy which the new criticism ascribes to every national art. As an exclusive principle in this sense the representation of space was declared proper to Roman art.[75]

Thus, in spite of previous warnings by Strzygowski and others, the Roman reliefs were once more recommended as a testing ground on which to prove the Romanitas of Roman art. But the result, this time, must seem frankly disconcerting. In the first place, the experience of space is generally human and its expression a fundamental problem of all art. Therefore it is from the outset unlikely that concern with space was in antiquity the exclusive characteristic of only one art, the Roman. At least in this unqualified form, the proposed antithesis between spatial (Roman) and nonspatial (Greek) representations cannot be right. Secondly, this theoretical contrast is by no means evident in the monuments. One cannot even assert that from the flat reliefs and paintings of Egyptian art the space problem is entirely absent. It would be more correct to say that Egyptian pictorial representations suppress or exclude the rendition of space, in order better to adjust the forms of objects to the pictorial medium, the plane surface. Greek artists were still less willing to disregard the experience of space. Far from excluding it from representation, they invented two devices which definitely possess a spatial significance: the oblique representation of figures and objects and optical foreshortening. Consequently, they introduced the

75. The thesis of the nonspatial character of Greek in contrast to Roman art was first put forward by G. Rodenwaldt, who soon abandoned it. See the informative review of Sieveking's and Weickert's theories by F. Koepp, in *GöttNachr* (1926) : 337.

problem of space into the active practice of western art. The question can only be how far they carried it.[76]

On the other hand, the latter question must also be considered with regard to Roman art. The visual evidence—our only criterion in such matters—does not favor the idea that the reliefs of the Ara Pacis represent "unlimited depth of space,"[77] and one must ask with Riegl whether such a concept was not beyond the reach of ancient art altogether. Wickhoff compared the effect of certain Roman reliefs to the airy effect of paintings by Velasquez. However, let us compare Velasquez's *Surrender of Breda* with the *Surrender of the Dacians* from the Column of Trajan. In either case the embattled town lies in the background, but where is the unlimited depth of space? It is certainly not found in the Roman work. There is a difference not only of degree but of principle between these representations, the difference between "ancient" and "modern," which Riegl had upheld against Wickhoff.[78] A history

76. A critical review of modern research dealing with this question may begin with the study by A. della Seta, "La genesi dello scorcio nell'arte greca," *MemLinc* 12 (1906) : 122 ff. Della Seta correctly observed the Greek origin and basic importance of *scorcio* (foreshortening) and *obliquità* (oblique representation) as means of spatial expression. For an immediate and still interesting reaction to his essay, cf. E. Strong, *CR* 21 (1907) : 209 ff. Other critical objections to the modern thesis that "space" is an innovation of Roman art: above, n. 75. Perspective in Roman art: below, n. 78; for the concept of frontality, see the following pages.

77. Weickert, "Gladiatoren-Relief," p. 38: "the penetration into space and unlimited depth (*Eindringen in unbegrenzte Raumtiefe*) is common to all the reliefs of the Ara Pacis and distinguishes them from all Greek works. . . ."

78. *Kunstindustrie*, pp. 60 ff. Perspective in ancient art and the ancient representation of limited depth: see below, pp. 62–65. The survey of recent research in M. S. Bunim, *Space in Medieval Paint-*

of spatial representation which ascribes nothing to Greek art and gives everything to Roman art is bound to err in both directions.

This is not to deny that a characteristic attitude toward space can be identified in many, or perhaps all, Roman reliefs. The legitimate question can only be, what is special to the Roman attitude toward space? The claim that a concern with space is innate in Roman art and not found in Greek not only seems a curious exaggeration. It actually reverses the facts; Greek art exhibited a sense of space long before Roman.

Nevertheless the two essays by Weickert and Sieveking constitute a considerable progress of knowledge; the new phase of Roman studies owes much to them. It should be emphasized that during the past decades our grasp of the realities of Roman monuments has become much firmer than before, and that the progress is due to archaeological research of this kind. The investigations of Roman art prior to Augustus by Weickert and the reexamination of the Roman reliefs by Sieveking give a more consistent and realistic idea of the subject than their predecessors could afford. The reason is to be found in the greater number of monuments included and a more critical insistence on their relative and absolute chronology. At least in its general outlines the chronological sequence of the Roman reliefs as suggested by Sieveking has proved acceptable.[79] His concept of a certain dualism in Roman art, too, seems consistent with the facts and

ing (New York, 1940), pp. 22 ff., can serve as a starting point for further studies.

79. For instance, J. M. C. Toynbee, _The Hadrianic School_ (Cambridge, 1934), pp. xxviii ff.

can even be accepted by those who would not accept his use of the terms *Greek* and *Roman* as distinctive, stylistic labels. Thus the reader is left with a peculiar impression. He deals with the apparent paradox of a scholarly method which has led to objective and, at times, acute observations of detail but has proved strangely prejudiced in matters of principle. Yet the principle in question, the representation of space in Greek and Roman art, cannot be a matter of speculation. It concerns a visible quality of art and consequently something to be actually seen, not merely surmised, in the works which possess it. One might expect that the question, whether or not a relief or painting shows space, can always be settled by consulting the monuments. That it was not so settled but became controversial in the modern appreciation of classical art is in itself a curious fact. Here appears a dilemma whose impact is still felt in the present state of Roman studies.

An interesting methodological factor must be mentioned here, because it contributed to this situation. If one follows the literature on Roman art during the first three decades of our century, a gradual change of meaning can be observed in the technical terms which refer to space. These terms acquired much prominence in the discussion; yet, while gaining in popularity, they became less precise. They degenerated, as it were.

The change, apparently, went quite unnoticed. To proclaim spatial representation as the intrinsic (national) characteristic of Roman art was from the start neither a natural nor a judicious choice, not because space does not play a sufficiently important role in

Roman art but because the interest in space is not exclusively Roman. Obviously the choice was made under the influence of the earlier theory of Wickhoff. But Wickhoff's theory was one of evolution. The development, as he saw it, proceeded from limited to free space. Greek art had already reached the former stage, while the last was attained only by the Romans. The errors involved in this theory need not be discussed here. It is not superfluous, however, to point out that space was thereby introduced as a principle in evolution and not as the exclusive badge of Roman art. Insofar as Wickhoff thought of the illusionistic attitude as an originally Italic tendency which enabled the Romans to develop space representation to its fullest, he paved the way for a nationalistic interpretation of Roman art. But in claiming space itself, not illusionism, as the characteristic of Roman art, the later writers obviously oversimplified his theory, against the evidence of the monuments.

Riegl, too, thought in terms of a universal evolution. He called attention to the gradual formation, in ancient paintings and reliefs, of a separate foreground plane which forces the eye to imagine the ground behind it, i.e., the material ground, as space. By the end of the Roman period pictorial practice had completed the separation of the two grounds; this development formed the essential content of the Roman *Reichskunst*, or Empire art. Again, neither the defects nor the astuteness of Riegl's observation are here at issue. We should notice, however, that this fundamental development of spatial vision was localized in two well definable, structural elements of pictorial composition. Riegl described a gradual change of emphasis from the

material ground—the "neutral" ground of earlier re-
liefs—to the optical plane which forms a "fore-
ground," because we recognize space behind it. In
other words, he envisaged a change as precisely de-
fined as that which, in music, led from the Gregorian
organum with its emphasis on the stable *cantus firmus*
to the Renaissance *canzone* with its subordinated ac-
companiment. He thought of this evolution as an ob-
jective and always controllable process and demon-
strated it by way of concrete factors which create
spatial illusion in a painting or relief.

In the subsequent discussions this precision was
lost. One probably does not go wrong in assuming
that with most later writers, including Sieveking and
Weickert, *space* generally refers to illusionistic repre-
sentations. Yet no need was felt for more specific defi-
nitions nor for a clear differentiation between the aims
of Roman art regarding space and modern, naturalistic
portrayal of spatial effects. This lack of precision is
confusing.[80] While the experience of space is always
the same, its renditions vary. In ancient art, both pre-
classical and classical, spatial devices are sometimes
found, which are decidedly not naturalistic in the
modern sense. Nevertheless, they may have conveyed
a full spatial experience to their makers and contempo-
raries. In the absence of an objective distinction be-

80. J. M. C. Toynbee, op. cit., p. 177 and n. 3, concerning the
alleged contrast of spatial representation in the Niobid sarcopha-
gus of the Lateran, and the one in Venice: "I must confess that in
my own case a comparison of the Lateran Niobid sarcophagus
with the Venice version of the same subject (Sieveking's fig. 4) is
very far from making 'die prinzipiellen Unterschiede sofort klar, so
dass keine weiteren Worte darüber nötig sind.' "

tween the various kinds and degrees of spatial repre-
sentation the danger is that the attribute "space"
becomes arbitrarily assigned to one kind of represen-
tation only and denied to others. It is a tendency of
the modern, nineteenth-century naturalism to ac-
knowledge space only in the "photographic" rendition
of depth. This circumstance may at least partly explain
the subjective verdict of those who deny all spatial in-
tentions in Greek art.

A similar, involuntary though consequential, distor-
tion of meaning occurred with the term *frontality*. This
term was originally coined by J. Lange, and soon be-
came common in the discussion of ancient art.[81] Riegl
adopted it. The enthroned emperor in the Constan-
tinian reliefs from the Arch of Constantine reminded
him of J. Lange's "law of frontality" (*Kunstindustrie*,
47); he also applied the term to Constantinian portraits
(109). These observations received a new slant, how-
ever, in his discussion of the diptych of Felix, in
which he found the rigidity of ancient-oriental and
Greek archaic frontality "restored" (114). It is the latter
expression which proved confusing. The law of fronta-
lity, as formulated by Lange, pertains to Egyptian
statues in the round, and in all other preclassical styles
where this formal systematization of the human figure
was used it remained distinctive of statuary. It was
not characteristic of reliefs or paintings, in which, on

81. J. Lange, "Gesetze der Menschendarstellung in der primi-
tiven Kunst aller Völker und insbesondere in der aegyptischen
Kunst"; a summary of the first part of this essay (first published in
1892) is reprinted in J. Lange, *Darstellung des Menschen in der
älteren griechischen Kunst*, ed. by C. Jørgensen and A. Furtwängler
(Strasbourg, 1899), pp. xii ff.

the contrary, frontal figures were much the exception. Therefore it was incorrect to say that in the Felix diptych, which is a relief, frontality was restored.

Riegl himself stated the case more correctly in his chapter on painting. Late Roman primitivism was not the return to an ancient, preclassical principle of art; it was something new. In late classical and Byzantine reliefs and paintings, the human form became "typified in a facing position, just as once with the Egyptians, figures were typified in side views" (130). The distinction between representations in the round and in the plane, though fundamental, is commonly disregarded in the subsequent discussions of frontality. The resulting errors become clear in statements like the one by Mrs. Strong that Greek art in compositions involving more than one figure "had never entirely freed itself from the trammels of 'frontality,' and consequently failed to apprehend or convey the relations of objects to one another in space" (*Roman Sculpture*, 20). This assertion is, of course, not at all in agreement with the monuments. The chief characteristic of Greek classical and Hellenistic figures is not frontality but the three-quarter pose of the heads.[82] The ultimate replacement of that pose by a full-face frontality may, with Morey, be called a turn towards

82. Mrs. Strong later described the contrast between classical and late-classical composition more correctly. It is the "union of centrality or convergence with frontality which distinguishes Roman from Greek composition in relief," *Apotheosis and Afterlife*, 36. Meantime, however, the idea that late classical art "returned" to frontality has taken hold of modern criticism. A comparatively recent example is found in E. Buschor, *Die Plastik der Griechen* (Berlin, 1936–37); cf. R. Bianchi Bandinelli, *La Critica d'Arte* 3 (1937) : 278.

FIGURE 4
Relief representing the enthroned emperor, from the Arch of Constantine, A.D. 315, *Rome.*

primitivism. But here again we must make an exception. At least in the eastern Mediterranean area, this type of pictorial representation constitutes a postclassical, not a pre-Hellenic, form of primitivism.[83] In paintings and reliefs the Byzantine preference for facing figures was not a restoration but an innovation.

The Present: Two Approaches to Roman Art

By now we have described almost all the methods and ideas which have become basic to research on Roman art in its present state. We may deal more briefly with the following literature. In the very active research after 1926 one is not likely to meet many basic concepts which cannot be readily understood as the natural consequences, or variations, of those already explained.

The thesis that concern with space was an Italic or Latin characteristic after Sieveking found few adherents.[84] In direct opposition to it, A. Schober not only stressed the sense of sculptural roundness and spatial depth in Hellenistic reliefs, but maintained that precisely the opposite qualities were those of the Italic style. Far from favoring spatial effects, the genuine Italian preference was really for flat and linear rep-

83. The return of frontality in Constantinian art was (after Riegl) extensively discussed in A. Schmarsow, *Grundbegriffe der Kunstwissenschaft* (Leipzig and Berlin, 1905). Cf. C. R. Morey, *Early Christian Art*, pp. 26 f.

84. For instance, C. C. van Essen, "Notes sur quelques sculptures de Delphes," *BCH* 52 (1928) : 231 ff., classified the frieze from the monument of L. Aemilius Paullus at Delphi as "Latin" because of its spatial quality.

resentations.[85] About the same time G. A. S. Snijder too claimed plastic roundness as intrinsically Greek and linear representation as Roman. By way of this contrast he presented the development of Roman art as the gradual liberation of a native, linear style from foreign, Greek influence. The linear style during the early empire survived as "folk art" but came into its own after Hadrian.[86] The same idea, that late imperial art was more genuinely Roman than the art of the early Empire, can be found in other writers of the nineteen twenties (see above, p. 54).

It is obvious that these theories not only oppose but exclude each other. We shall not, however, conclude that therefore only one can be right, and that Roman art must be either flat or spatial. Nor should we say that the concepts themselves are necessarily discredited by these contradictory results, or that they have proved unsuited for the objective analysis of works of art. This controversy merely illustrates our previous statement, that the term *space* is too general for the effective investigation of Roman art. What must take place, instead, is an investigation of the various specific devices which express spatial experience in ancient art.

Indeed the need for differentiations within the general concept of space was soon felt and, at least once, expressly formulated.[87] But even when this need was

85. A. Schober, "Vom griechischen zum römischen Relief," *JOAI* 27 (1931) : 46 ff.

86. G. A. S. Snijder, *Romeinsche Kunstgeschiedenis* (Groningen, 1925). The same author, "Der Trajansbogen in Benevent," *JOAI* 41 (1926) : 94 ff.

87. F. Matz, *AA* (1932), pp. 280 ff.

recognized, the greater difficulty at this stage of the discussion arose from the belief that Roman art must differ from others by some special, formal principle and not merely by changes of time or subject-matter. As a principle of this sort, to prove the originality of Roman art, space had been tried and failed. No more could linear representation be limited to Roman art alone. In a somewhat earlier article A. Schober correctly observed that linear styles were indeed characteristic of all the provincial arts practiced along the edges of the Empire. Accordingly it seemed as if the genuine Roman style, being flat and linear, was carried to its victory by the "increasing influx of foreign blood"—Germanic and Oriental—at the time of the internal dissolution of the Empire: not a plausible reconstruction of Roman history.[88]

A general remark seems here in order. However much these interpretations contradict each other, they have a common starting point. They all belong to one methodological category. With a theoretical rigidity which often makes their classifications seem wilful and pedantic all these studies attribute the exclusive use of an artistic style to a single ethnical group. They rely, however tacitly, on the assumption of innate and immutable national characters. As we stated before, this is the principle of nationalistic art criticism. But it is difficult, if at all possible, on this basis to account for the cultural changes of the ancient world. If national characters are imagined as so permanent that each represents a distinct and stable cultural trend, then a change of ethnical elements is indeed the only

88. A. Schober, "Zur Entstehung und Bedeutung der provinzialrömischen Kunst," *JOAI* 26 (1930) : 50 ff.

explanation of cultural and artistic changes. New styles of art must come from new races of people.[89] In reality, this assumption is quite uncertain. Thus far all attempts at distinguishing between definite national or racial styles in Italy—Etruscan, Latin, or Roman— have produced mere theoretical fictions. The ethnical conditions of the peninsula neither explain the stylistic changes nor all the local differences in the arts of ancient Italy.

About this problem more will have to be said later on, but one other relevant point must be mentioned here. In surveying the stylistic descriptions and the deductions drawn from them in this group of literature, one cannot help noticing that the esthetic evaluation of Roman art has remained very uncertain. This factor adds another complicating element, especially to the study of late classical art. If one judges the antinaturalistic style of the late empire as a decline of art, then it is possible with Sieveking to arrive at the verdict that the Roman (illusionistic and naturalistic) substance was ultimately dissolved by foreign influences from the East. If on the other hand the late Roman style is viewed more sympathetically, it may be explained as the ultimate liberation of the native substance from foreign, classical influences.

These conflicting opinions by their very contrast show how arbitrary it is in the complex texture of Roman art to single out one element as more Roman than others. Nevertheless the efforts to define the elusive Romanitas continue.[90] In each case the quest is

89. Cf. above, n. 73.

90. V. Mrs. E. Strong, "Romanità through the Ages," *JRS* 29 (1939) : 137 ff., and J. B. Ward-Perkins, "The Italian Element in

for the distinctive attributes of the Roman national character, postulated as a set of permanent traits, an inherited disposition, or a quasi-personal development.[91] The assumption of a single, Roman principle of style remains characteristic of all these writings.

Having established the existence of this group in modern Roman scholarship, we must now turn to its opponents. The philhellenic interpretation, to call it so, still constitutes another important trend in the Roman controversy. It leads to a different, if not new, theory of Roman art. Fundamentally, it represents the modern continuation of Winckelmann's verdict that there is not a Roman art but only a Greek art under the Romans.

As we saw, this theory originally implied a negative esthetic evaluation of Roman art. Winckelmann felt very strongly the loss which occurred with the transition from Greek classical to Roman art. The change, indeed, was a radical one. It involved basic intentions, indeed the very scope, of art, for the nature and function of form in art were redefined under the Romans. Here we must recall another circumstance which regards modern criticism. The common neoclassic taste, which developed during the eighteenth century,

Late Roman and Early Medieval Architecture," *Annual Italian Lecture of the British Academy in Rome* (London, 1947) : 5 and 22, n. 8.

91. For the latter opinion see A. Grenier, *Le Génie romain dans la religion, la pensée et l'art* (Paris, 1925) and his conclusions, pp. 462 ff. This book has a wider scope than the investigation of art alone. It aims at a cultural and spiritual definition of Roman national attitudes. With regard to the formative arts, Grenier follows the line of strictest philhellenism: there is no Roman style, only a Roman content, of art (463).

in general promoted a rather one-sided appreciation of Greek art. The ill-defined yet hard-dying slogan of the "idealism" of Greek art is one of its results. Another is the misapprehension of Greek art as an example of naturalistic representation.[92] A naturalistic component undoubtedly existed in Greek art, although its meaning and intensity were not the same at all stages of its history. Neoclassic theory and practice felt much attracted to this aspect, which they interpreted in terms of the scientific naturalism which inaugurated the art of the nineteenth century: witness the Greek revival in the paintings from David to Ingres. Thus was formed the criterion of "beauty and animation," the formula in which Riegl summarized the popular interest in art at his own time (see above, p. 34). *Animation* can, of course, mean many things, but here the term certainly expresses the demand for naturalistic representation in the modern, scientific sense.

This trend has not yet run out. For instance, whenever someone blames the reliefs from the columns of Trajan for their lack of perspective or faulty perspective, he is apt from the modern point of view to judge them in a doubly negative way. He may appraise them as the obvious decline of those earlier classical traditions, which to the modern naturalistic taste give less offense, and thereby judge them not as examples of a Roman art in its own right but as inferior specimens of Greek art.

Therefore, likewise since Winckelmann, with the negative criticism often went a denial of the original-

92. Cf. C. Seltman, *Approach to Greek Art* (London and New York, 1948) and my review in *Magazine of Art*, October 1949, p. 233.

ity of Roman art. Yet, while the first problem may be held in abeyance as a question of personal taste, the second cannot be so treated. The originality of Roman art poses a genuine and objective question of the history of art. Even the philhellenic interpretation could not always ignore it.

In France, the homeland of neoclassic theories, a compromise solution was proposed by E. Courbaud in 1899. In his treatise on the Roman historical reliefs from Augustus to Hadrian, Courbaud found that the style of these works is Greek but the content Roman. At the same time his criticism of the reliefs as works of art is often negative; it includes the naturalistic objections mentioned above against the Column of Trajan.[93]

This interpretation reflects the change of general attitude toward Roman art after 1900 (above, p. 40). About that time the originality, rather than the existence, of Roman art became the embattled issue. (Cf. the remark of Mrs. Strong, quoted previously, p. 41). Winckelmann labeled Hellenistic and Roman art the period of the "imitators," unable to produce a Roman style because it lacked inventiveness and original ideas. Around 1900 the Roman monuments were generally viewed as a coherent group and not merely as isolated works of art. In this way the existence of Roman art could be recognized even by those who held a low opinion of its esthetic value.

The criticism that Roman art falls short of classical Greek or modern naturalistic standards or both can of course be raised at any time. The chapter called "Mu-

93. E. Courbaud, *Le basrelief romain à représentations historiques* (Paris, 1899). Cf. E. Strong, *Roman Sculpture*, p. 5 and note.

seum" in C. Seltman, *Approach to Greek Art* is a recent example and at the same time almost a revival of Winckelmann's theoretical condemnation of Roman art.[94] On the other hand, the critical value of a philhellenic attitude showed itself in the opposition to exaggerations like the theory that Roman art discovered the rendition of space. Thus, in reviewing the article by Sieveking, F. Koepp could well perceive the errors following from the axiomatic assumption of a national Roman style. That the method recommended by himself was hardly more effective is another matter. Instead of asking what is Roman, we are invited to ask what is Greek in Roman art.[95] But do we know better what we mean by *Greek* as a quality of art in the Imperial period? Are the neoclassic reminiscences Greek, which appear in Roman monuments like Greek quotations in a Latin poem? Are the Roman copies of classical works Greek art? And what, precisely, is Greek about the processions represented around the Ara Pacis Augustae? We might speak of Greek art in its Roman stage, and thereby describe most, if not all, Roman art after Augustus. But in adopting such parlance we beg the question. We indicate that this art is no longer Greek in a genuine and direct sense, that it is not really Greek. While substituting a more involved expression for a simpler one, we have gained nothing.

In such considerations it becomes quite clear that this entire controversy concerns a purely terminological question. Whether or not we call Roman art

94. See above, n. 92.

95. F. Koepp, "Kritische Bemerkungen zum römischen Relief," *GöttNachr* (1926) : 330.

Roman would be of very minor importance, if it were not for the two theoretical principles involved: on the one side the axiom of a Roman national art, on the other side the esthetic evaluation of Roman as a deteriorated form of Greek art.

One other, more objective criterion bears on this question. The available evidence indicates that the majority of artists and craftsmen during the Roman epoch had Greek, not Latin names. This observation, already made by Strzygowski (above, p. 44), was in 1926 demonstrated in greater detail by P. Gardner as an additional circumstance arguing against the originality of Roman art.[96]

One deals here with a sociological criterion which was undoubtedly symptomatic of the industrial organization in Rome as a whole.[97] Its specific impact on

96. P. Gardner, *New Chapters in Greek Art* (Oxford, 1926), chapter entitled "Art under Roman Rule," pp. 269 ff.

97. Greek names occur frequently among the lower middle classes of Italy (artisans, owners of small shops and workshops, physicians, teachers, etc.). The reason was the system of production through low-paid workers, imported slaves and freedmen, which formed the basis of Roman society during the Empire. In the cities these people formed a common element, but there is no indication during the first and second centuries A.D. that they were in a position to maintain distinct cultural traditions of their own. We must assume that they were quickly Romanized. It seems throughout that they spoke Latin; many could write it. What distinguished them from the higher classes—not all native Italians either—was not a cultural tradition different from the Roman, but their low educational standards. Cf. M. L. Gordon, "The Nationality of Slaves under the Early Empire," *JRS* 14 (1924) : 93 ff.; M. Rostovtzeff, *A Social and Economic History of the Roman Empire* (Oxford, 1926), pp. 178. For more recent discussions, cf. D. Levi, *Annuario* 24–26 (1950), pp. 232 f., and especially J. M. C. Toynbee, *Some Notes on Artists in the Roman World*, Collection Latomus (Brussels, 1951).

Roman art is difficult to assess. At various times of the Republic artists from Greece and south Italy are known to have moved to Rome, as did other artisans and intellectuals, especially during the Hellenistic period. Men like Apollonios of Athens must indeed be regarded as Greek artists, just as Michelangelo was a Florentine artist even though working in Rome. But the Greeks and other easterners who worked in Rome during the Empire present a different problem. They did not bring with them an important cultural tradition, but merely the skill which they put to use for the public of Rome. Here a historical factor comes into play which later will require more attention, namely the formation of cultural centers. The Hellenistic artists of the first century B.C. still transplanted into Rome something which she did not herself possess and which their own homelands possessed. A hundred years later conditions have changed. The Roman market still absorbed foreign specialties like Alexandrian silverware. But we know of no sculptural school abroad which could provide Rome with something superior to what she herself was then able to produce. Rome had become a center, toward which in turn others gravitated.

Therefore, if one wishes to assess the Greek share in Roman art, a distinction is needed between elements incorporated from earlier (Classical) and those from coeval sources. The contribution of Classical and Hellenistic Greek standards to Roman civilization is one thing, the contribution of foreign artists to Imperial art in Rome another. The latter is far from obvious and calls for renewed study. There is a limit beyond which it does not seem practical to call the works of artists with Greek names Greek art. The paintings of El Greco

are beyond this limit; so is the Ara Pacis. It is not un-
reasonable to assume that Greeks worked on the Ara
Pacis and other Imperial monuments, but to label their
work Greek art invites comparison with incommen-
surable objects, like the Parthenon or the Telephos
frieze from Pergamon. Such comparisons have indeed
frequently been made, P. Gardner's book forming no
exception in this regard. Only two relevant points
have really become evident by them. The esthetic
comparison, more often than not unfavorable to the
Roman monuments, shows that works like the Ara
Pacis are no longer Greek in the sense in which the
Parthenon or the Telephos frieze constituted Greek
art. Secondly, coeval Greek works comparable with
the Ara Pacis and similar Roman monuments are lack-
ing. In other words, ancient art has moved into a new
phase, undoubtedly with the cooperation of the
Greeks. But in order conveniently to refer to this new
stage, characterized by a style different from the pre-
ceding stages, a term other than *Greek* seems required.

The next step in the philhellenic direction is marked
by the book by Miss Toynbee called *The Hadrianic
School.*[98] The subtitle reveals its general trend: *A
Chapter in the History of Greek Art.* Aside from the the-
oretical bias, this is one of the soundest books on
Roman art among recent publications. Its scope is lim-
ited to an investigation of two classes of monuments
representative of art under Hadrian: the represen-
tation of provinces, mostly on coins, and the sar-
cophagi and other funeral reliefs datable to the reign
of Hadrian.

By this selection Miss Toynbee wishes to state a sig-

98. J. M. C. Toynbee, *The Hadrianic School* (Cambridge, 1934).

nificant contrast between official and private art. Characteristic of the former are political allegories. These constitute indeed one of the peculiar features of Roman Imperial art. If one recalls the popularity of allegories in Medieval and Renaissance art as a vehicle for the expression of abstract content, the importance of the matter becomes at once evident. Miss Toynbee does not attempt to credit this device to any one ancient school, either Roman or Alexandrian, but seeks its origin in common Greek art. In this assumption she is probably right, notwithstanding the fact that regional differences in the use of allegories can perhaps be identified in ancient art. Throughout, her book emphasizes the universal character of Imperial Roman art as the true successor of the Hellenistic. The introduction includes a valuable critical review of the contemporaneous, nationalistic interpretation of Roman art (xiii ff.).

Miss Toynbee herself champions the opposite interpretation, which we traced back to Winckelmann. There is no Roman art; "art under the Empire may be described as Greek art in the service of the Imperial idea" (xx). In other passages her concept seems more akin to Riegl's. "What we are accustomed to term 'Roman' art is not the art of the Roman people or of the Roman race, or Greek art under the Romans: it is Greek art in the Imperial phase, or, more concisely, Imperial art" (xiii; cf. Riegl's term *Reichskunst*). Therefore it seems to her "*not* strictly accurate to describe Hadrianic art as a 'Greek revival' " (xxi). Greek art never died; therefore it was not "revived" under Hadrian. This opinion explains the tendentious subtitle, which also squares with the opinion of P. Gardner.

Yet at the same time, Miss Toynbee detaches herself from the classicistic condemnation of late Roman art as a mere period of decline (239). The crux of this thesis lies in the difficulty of demonstrating the incessant flow of Greek art from the last century before Christ to the Hadrianic, neoclassic episode. This problem was not solved. On the other hand, it is the greatest merit of Miss Toynbee's book to recognize a continuity between Greek and Roman art (xx). She thereby renewed Riegl's call for a universalistic theory of Roman art. In this methodological demand, rather than in a mere dispute over terminology, indeed, rests the essential usefulness of all those interpretations of Roman art which for the sake of explanation are here classified as philhellenic.

At this point it becomes evident that the relation between Greek and Roman art can be explained in three possible ways. It can be stipulated as a strict contrast. This is the hypothesis of nationalistic theories, which, however, too often "draw unreal distinctions" (xx) between the two arts. It is certainly a modern anachronism to ascribe to the Romans a "resistance" to Greek art in order to preserve intact a special national style (xiii). Secondly, the relation between Greek and Roman art can be stated as one of complete identity by denying any basic distinction between them. In that case one assumes that *Roman* merely constitutes an advanced, or deteriorated, form of Greek art, as the case may be. This interpretation leads to the terminological deadlock explained above. Finally, the relation can be stated as a continuity. Of these three possible explanations, the first and second are entirely based on stylistic judgment. The third allows for a degree of factual,

historical control in addition to the stylistic evaluation. *Continuity* is a historical term. It must result from actual circumstances, wherever it is found. If one assumes a continuity between Greek and Roman art, it becomes both necessary and meaningful to ask how, in reality, this continuity was brought about.

A small number of other publications may be conveniently attached to this group because they deal with Roman art under the same aspect, the continuity of the classical evolution. This is definitely the case of the book by C. R. Morey on early Christian art, which we have mentioned before.[99] Again, the subtitle announces the methodological program: *An Outline of the Evolution of Style and Iconography in Sculpture and Painting from Antiquity to the Eighth Century.* In essence this was also the program of Riegl, but there are significant differences in the execution. Morey's demonstration relies less than Riegl's—less, also, than one might expect from its title—on the pure reconstruction of stylistic development. The acuteness and ingenuity of stylistic distinctions which one finds in Riegl are not the business of Morey. Instead he offers an attempt at describing the continuity of ancient art as a pragmatic history with an eye to the practical circumstances in which that art was created and distributed. Most important, this book calls for a consideration not of stylistic trends alone but of their actual, geographical centers. In a field of study as heavily burdened with theory as Roman art, every turn to historical realism must be welcome. The concept of cultural centers is one that makes such an approach possible.[100] As yet

99. C. R. Morey, *Early Christian Art* (Princeton, 1942).
100. Cf. the note on Strzygowski, above, n. 59.

it is little explored; we shall have to deal with this idea more fully in the future.

Development in separate centers, as during the Renaissance, was a characteristic of Hellenistic art. Most cities in which these centers were located continued under the Empire, e.g., Athens, Rhodes, Alexandria, and others. It seems natural to look to these places first, if one examines the conditions for a continuous evolution of art from Hellenistic to early Christian times. Unfortunately the local evidence is far from clear. During the Empire some of the old centers went out of production (e.g., Rhodes), though the cities remained, while new centers formed. Thus after Constantine the great cities of the world, the cultural centers, were Rome, Antioch, Alexandria, and Constantinople (*Early Christian Art*, 8).

During the Empire Athens still functioned as a center of art, which also affected the provinces of Asia Minor with its conservative, "neo-Attic" taste. One chapter in Morey is dedicated to this trend (17 ff.). Antioch was a newcomer. It became a center, at least of distribution, during the second century A.D. Yet its art, now better known to us through the recent excavations, remained generally Greek and Hellenistic and shows no distinctive style (30 ff.). Alexandria, on the other hand, probably remained an active center at all times. Morey tentatively ascribes to this city the survival of the progressive trends in Hellenistic art, especially painting (37 ff.), although thus far there is very little local material on which to base this judgment (38).[101] Finally Constantinople became a center

101. The arguments pro and contra an "Alexandrian" style of art were recently outlined by D. Levi, op. cit. (above, n. 97), pp. 293 ff., n. 1.

through imperial favor, but not before a time which lies beyond the life span of Roman art proper.

No place of comparable importance is assigned in this scheme to the first among Constantine's four world-cities, the city of Rome. In Morey's book Rome is not discussed as a possible center with a distinctive influence on the history of art. His concern is with the differentiation between the principal currents of Hellenistic art and their survival. Therefore, from his point of view the role of Rome appears as passive and receptive rather than active and central. Also, in this theory the esthetic evaluation of late classical art is mostly negative, pro-Hellenistic. The disintegration of the Hellenistic style in the East is credited to Iranian influence (34), in the West, to the action of a Latin trend replacing Hellenistic "representation" by piecemeal "description" (55 ff.). Thus in both halves of the ancient world, though in each for a different reason, the trend is regressive. In this respect the evolutional scheme suggested by Morey is more philhellenic than that of Riegl. The latter was well aware that a degree of decomposition must follow in any art from a principle of "vision" which isolates forms instead of integrating them, but in his own theory he nevertheless perceived a progress from "normal," conceptual to empirical, "optical" representation.

The above reconstruction of Hellenistic-Roman continuity receives its bias from the unfavorable evaluation of the Roman part. It is obvious, however, that the historical assumption on which it rests, that of simultaneous evolution in separate centers, has a merit independent of this particular interpretation, and it is equally obvious that other interpretations of the same theory are possible. In fact, if one sets out to in-

vestigate the possible centers of artistic production after the Hellenistic era, it is difficult to see as a matter of method how the city of Rome can be omitted from consideration. No other metropolis of the Empire offers so much local material of such importance. Rome had its Hellenistic phase and its Imperial art both official and private; many monuments are still extant. Significant changes can be observed in this material, all of which seems indeed to point to a continuous local production over a considerable period— in short, a center.

Any investigation of Rome as a center—possibly only one center among others—brings a new historical and sociological concept to bear on the problems of Roman art. The methodological consequences of this idea have yet to be fully realized. Roman art so considered is not the spontaneous growth of a "native" style, not a national art with ultimately inexplicable though stable, because innate, characteristics. Neither is it a mere transition in a rational progress of universal art. Instead, in this conception Roman art is recognized as a cultural, not a biological, phenomenon, a product of tradition, not of inheritance. As the outcome of a unique historical situation it is itself unique. It appears inscribed within a set of definite conditions, growing from a limited locality rather late in history. As it grew, the impact of the past and foreign contacts acted upon that art in ascertainable ways. By and by the ancient city acquired the absorbing capacity and radiating force which together constitute a cultural center. In the same way the earlier Hellenistic schools operated in centers which were formed either by special efforts (Pergamon, Alexandria) or

characteristic political and economic constellations (Athens, Rhodes). Each time the process of formation involves precise and individual circumstances, such as the conflux of cultural trends, the collaboration and immigration of important artists, specific purposes of art and similar factors. In Rome also concrete and objective evidence of this kind can be observed. A great deal of available information as well as monumental evidence recommends the study of Roman art as the creation, primarily, of a center located in Rome.

This idea, which rests on a concept of cultural history, has lately gained ground in the literature on Roman art, though its methodological implications have received only passing attention. Miss Toynbee briefly described in these terms the status of Rome at the start of the Imperial era.[102] More recently R. Bianchi Bandinelli has given a similar account in somewhat greater detail of the transformation of Rome into an artistic center. From the first century before Christ onward, the peculiar influence—really a provincialism of "taste"—of the new center is felt in and beyond Italy. This marks the beginning of "Roman" art.[103]

Emphasis on Rome as the center and source of Roman art is not, of course, compatible with the philhellenic interpretations from which this paragraph

102. *The Hadrianic School*, p. xx.

103. R. Bianchi Bandinelli, "Tradizione ellenistica e gusto romano nella pittura pompeiana," *La Critica d'Arte* 6 (1941) : 3 ff.; especially the final paragraph, p. 30. He is one of the few modern authors who explain their use of the term *Roman:* it should be employed as a convenient term of classification, referring to a historical period but without the connotation of an art exclusively Roman by origin. Cf. the similar but more explicit remark of Riegl, quoted above, p. 5.

started. Here we are concerned to point out the common elements which these theories nevertheless possess. Common to all interpretations in this category, however divergent their evaluation of the Roman factor, is an idea of continuity and evolution.[104] *Greek* and *Roman* are not conceived as rigid opposites; a dynamic process, history, has somehow fused them in a continuous development. In this thought the Renaissance idea of a "classical" antiquity survives enriched by modern historical experience. Yet the idea of evolution, too, is a theoretical assumption. We do not know in reality what evolution is or means. It may mean quite different things; a tree develops differently from a financial crisis. What, then, developed in Roman art? How did it develop? And to what end?

Several of the familiar Roman problems come to mind when these questions are asked. The origin of Roman art among the various provincial styles of early Italy is one such problem; the formation of a Hellenistic center in Rome, the motivation of its stylistic changes are others. Yet all these are comparatively detailed and special questions, however important. The question of paramount importance is the most general and most obvious of them all: how did the Classical, Hellenistic and Augustan tradition turn into the late Roman style with its symbolical formalism, emotional expressionism, and indifference to distortion? This is the question which every theory of evolution (or decline) undertakes to answer before all others.

It is also the most conspicuous question not yet an-

104. J. M. C. Toynbee, *The Hadrianic School*, p. xx: "Rather, we should see in that ancient art one continuous process of evolution, etc."

FIGURE 5
Section of the reliefs on the Column of Trajan,
A.D. *113, Rome.*

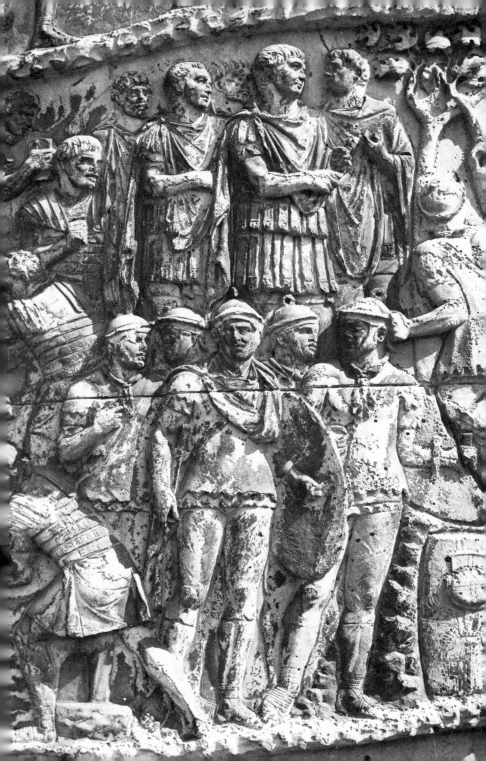

swered among the Roman problems. This must seem a curious fact, because since the time of Winckelmann the question has been incessantly discussed, and there is no lack of material for study. Yet so far no agreement has been reached about the time or even period at which the late Roman or late classical style may be supposed to begin. We need only quote a few opinions of modern critics in order to recognize the symptomatic significance of this disagreement. Thus K. Lehmann detected the first precise signs of the late classical style in the Column of Trajan.[105] His book, fundamental for its stylistic analysis, aligns itself with the present group of "universalistic" art histories because of its concept of a continuous, Hellenistic-Roman development. From this point of view the Column of Trajan indeed appears as a decisive example of the transition from Hellenistic-Classical to late Classical habits of representation. On the other hand, M. Wegner, applying a similar analysis to the Column of Marcus Aurelius, found in the latter the likely starting point of late Roman art.[106] Not far from his opinion is the conclusion of Miss Toynbee, who sees "in Hadrianic art the culmination of Imperial art." That is to say, in her view too the turning point of Roman art occurred after Trajan. It was really incorporated in the Janus-faced Hadrianic period, whose spirit "can be traced right on through the art of the later Roman Em-

105. K. Lehmann-Hartleben, *Die Trajanssäule; ein römisches Kunstwerk am Beginn der Spätantike,* 2 vols. (text and plates) (Berlin and Leipzig, 1926), pp. 152 ff.

106. M. Wegner, "Die Kunstgeschichtliche Stellung der Marcussäule," *JdI* 46 (1931) : 61 ff.; especially 167 ff. and 173. This is also the opinion of D. Levi, *Annuario* 24–26 (1950) : 262 ff.

FIGURE 6
Section of the reliefs on the Column of Marcus Aurelius, ca.
A.D. *180–193, Rome.*

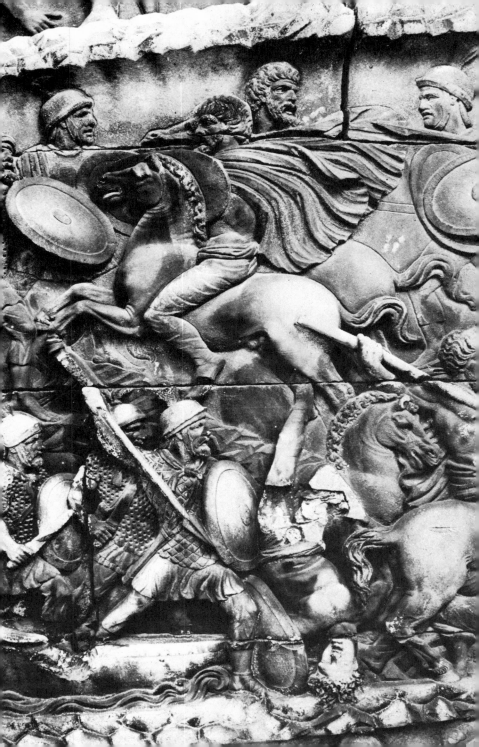

pire."[107] Yet C. R. Morey, himself no less concerned with the continuity of ancient art, in turn reached a completely different conclusion regarding this crucial chronological division. According to him the process of transformation which led to the late Roman style began during the age of the Flavians.[108]

These are four representative answers. Each can be supported with good reasons; none has proved strong enough to defeat the others. An interesting methodological remark can be made, however, if one reviews the grounds adduced for each of these contradictory statements. Naturally the explanation each time refers to certain stylistic details characteristic of the monument or monuments in question. Such details are the nonnatural representation of spatial relations (columns of Marcus Aurelius, of Trajan), the preference for allegories (Hadrianic period), distortions for the sake of descriptive clarity (Arch of Titus), and other similar peculiarities of representation. In themselves, all these observations are correct. But in almost every case one must doubt that a similar stylistic device cannot be found in other, earlier Roman or Hellenistic representations. For instance, the use of superimposed objects to indicate spatial distance occurs in the Pergamene Telephos frieze as well as the Column of Trajan. The result does not look quite the same in both instances, but the difference appears to be one of degree rather than of principle. And in that case, where is the real origin of this "late classical" device? Similar observations may be made with respect to most other details cited, for instance, the use of allegories. Actually the

107. *The Hadrianic School*, p. 239.
108. *Early Christian Art*, pp. 50 f.

tendency already becomes apparent to date the turn toward such symbolical, nonnaturalistic forms of representation to the early Empire rather than to any late period of decline (Morey).

Why is it so difficult to find a conclusive answer to this problem? Any picture book on Roman art proves that it is easy to recognize the late classical character, for instance, of the Constantinian reliefs in the Arch of Constantine. Likewise the non-Classical, antinaturalistic forms of landscape and perspective in the columns of Trajan and Marcus Aurelius are not difficult to perceive. If no other Roman monuments were known to us between these two works one would indeed judge them to be examples of a direct evolution of style. One would recognize the beginning of the new style in the time of Trajan, its progress in the time of Marcus and its further development in the Arch of Septimius Severus and beyond. Yet between the columns of Trajan and Marcus lies the period of Hadrian. For approximately fifty years, instead of a consistent development of late Classical representation, one finds a pseudo-Classical style of art. Similar interruptions of continuity separate the Flavian reliefs from those of Trajan. Moreover, the late Classical devices in the reliefs of the Column of Trajan appear side by side with others that seem perfectly Classical; in many respects, one deals here with a mixed style of representation. Therefore the continuity, i.e., the unifying principle of development, is difficult to discover in the sequence of datable monuments of the Empire. There seems to be neither straight progress nor decline, only a variety of more or less changeable fashions. Once attention has been called to these ir-

regularities the late Roman development in Imperial art becomes much more difficult to define. Ultimately, it becomes doubtful whether a theory of continuous evolution is at all suitable to account for the facts of Roman art.

General Character of the Foregoing Theories

All this previous research can now be considered as a whole. First, we should remark that this research constitutes a modern reaction to Roman art; it is not the Roman interpretation. The latter remains almost wholly unknown to us, nor is it likely that we shall ever know much about it. In this condition, which must be accepted as inevitable, lies the greatest difference between all modern investigations of Greek art on the one hand and of Roman on the other.

It is a fact of basic importance that the Greeks wrote their own history of art. At least from the early fifth century before Christ onward they possessed a developed theory of art, put down in writing; very likely they invented methodical art criticism. The Greek history as well as theory of art was accessible to the Romans. Important fragments of both types of writing have come down to us in Latin literature, e.g., in the books of Pliny and Vitruvius. From these sources the modern studies of Greek art received their direction. They derived from the ancient writers a basic catalogue of artists' names, a scheme of chronology and, in addition, certain critical evaluations of the works of these artists. Ancient criticism had already put these materials in a historical order, and Hellenistic writers

described the development of Greek art.[109] The historiographical pattern has remained in effect ever

109. Fundamental, for the Greek conception of the history of art: B. Schweitzer, *Xenokrates von Athen* ("Schriften d. Königsberger gelehrten Gesellschaft" 9, fasc. 1, Königsberg i. Pr. 1932); additions by the same author, *Philologus* 89 (1934) : 286 ff. More recently, about the Greek theories of art and their descriptive terms: S. Ferri, "Tendenza unitaria delle arti nella Grecia antica", *Atti R. Accademia di Palermo*, ser. 4,2 (Palermo, 1941); *MemLinc* 4 (1944) : 1 ff. See M. Bieber, "Pliny and Graeco–Roman Art," *Latomus* (1949), and the useful survey in G. Becatti, *Arte e gusto negli scrittori Romani* (Florence, 1951), pp. 50 ff. The Greek theories of art require more attention than has been given to them. It is necessary to distinguish between professional criticism, philosophical theory (esthetics), and popular appreciation. Professional criticism was developed by artists and in artists' workshops, much as during the Italian Renaissance. From at least the early fifth century B.C. on, Greek artists possessed a definite critical vocabulary; works of art—statues, architecture, and paintings—were described and criticized in abstract terms, such as *rhythm, symmetry,* etc. The meaning of these terms does not always coincide with modern usage. For instance, *symmetry* means a rational system of distances and proportions underlying the arrangements of parts in a statue or building; it does not signify equality of parts on either side of a middle axis as in modern languages. The precise significance of many terms has not yet been established. It seems likely, however, that most of them refer to qualities of form. The leading artists experimented with these systems of proportions and the resulting problems of form, creating thereby a progressive theory of formal criticism.

This was hardly possible without a written tradition, i.e., a professional literature. According to the ancient tradition, Pythagoras of Rhegium was the earliest artist who studied "rhythm and symmetry" (Diogenes Laertius, 8. 46). I assume this statement to mean that he first wrote on the subject. The most famous book of this kind was by Polycleitus, the *Kanon.* This professional literature probably continued till Lysippus, but ended during the Hellenistic period; cf. below, n. 111.

since. A skeleton history of art can be gathered from these bits of information which is deplorably incomplete and in need of correction but whose evolutionary scheme can still be used. Other ancient, critical categories as yet have hardly been utilized. Despite the shortcomings of our sources, the Greek interpretation of Greek art is not altogether beyond our reach.

The study of Roman art has no comparable resources. The Romans, who cast their political history in so grand a form, apparently never wrote the history of their art. Data on art and scattered names of artists occur occasionally in Roman historical and moralistic literature, but only as episodes. For instance, the notorious opposition to Hellenistic taste on the part of the elder Cato and his followers forms an episode of definite theoretical interest.[110] But isolated historical notes cannot make up for the lack of a methodical, professional history of art. A flareup of critical interests during the decades between Sulla and Augustus did not consolidate in a Latin literature on art.[111] Con-

110. The "Catonian" attitude toward art constitutes an important trend in Roman thought, which marks the beginning of the complaints, often repeated since, that art not only develops but at times seems to decline. The thought itself, no less than the terms in which it is expressed, differs from the characteristic professional terminology of Greek artists. It constitutes a case of popular, rather than professional, art criticism.

111. Pliny makes the curious remark that after 296 B.C. art ceased to exist (*cessavit deinde ars*, N.H., 34. 52). This cannot mean that artistic production stopped, which obviously was not the case. Possibly the remark refers to the end of "art" in the sense of classical, formal theory (*ars* = Greek σοφία). If the latter explanation is correct, we must assume that after Lysippus theoretical dis-

temporary critical remarks about Roman artists and their works are extremely rare; the few which are preserved lack the precision found in Greek criticisms.[112] Nothing is known to us about artistic theories in the time of the Empire, which deal with the contemporaneous style or its development. It seems that the artists were no longer writers, as the Greeks had been, and that society held their vocation in such low esteem that a theoretical interest in their work did not develop or, at least, become articulate. There is no Roman theory of art.

Because of this circumstance the modern studies of Roman art are forced to draw on their own methodological and critical resources. They are left without guidance from the makers and the original public of that art. The few surviving names of Roman artists are not sufficient to provide a recognizable context of art history. The chronology of extant Roman works before Augustus is still very uncertain and Imperial art al-

cussions ceased to occupy the artists, or at least that treatises were no longer written on this subject. Neo-Attic art brought with it a temporary revival of these interests (after 156 B.C.; Pliny N.H. 34. 53). The entire passage in Pliny seems to reflect the opinions of Pasiteles, who was himself an artist-writer and perhaps the last to summarize the ancient theories of form. Latest contribution to this problem: A. W. Lawrence, "Cessavit ars: turning points in Hellenistic sculpture," in Mélanges d'archéologie et d'histoire offerts à Ch. Picard, 2 (Paris, 1949), pp. 581 ff.

112. Notes of social and anecdotical interest often take the place of professional criticism in Roman literature. Conspicuous is the one-sided preference for painting as the socially better respected art in contrast to sculpture, as e.g., in Pliny or Lucian; cf. J. M. C. Toynbee, "Some Notes on Artists in the Roman World," pp. 1 ff.

most totally anonymous.[113] Nor is any clue available to tell us how the ancients themselves might have written the history of Roman art under the Empire. The esthetics and the development of that art must be deduced directly from the monuments. Therefore the selection of Roman representative artists, masterworks, or standards of criticism had to be improvised by modern students without the assistance of a previous selection made by the contemporaries or near-contemporaries. In its dealings with all these problems modern criticism is left to itself, to its own concepts and ingenuity. It is free, even to assert or negate the existence of a Roman art, as the case may be. Hence the essentially modern character of its categories but hence, also, its methodological controversies.

A second observation regards the present state of the theories which have been devised to meet this sit-

113. Fundamental, for the literary evidence of Roman art before the Empire: O. Vessberg, "Studien zur Kunstgeschichte der Römischen Republik," (*Skrifter utgivna av Svenska Institutet i Rom*, 8, Lund, 1941). This new source book takes the place of the previously mentioned compilation by J. J. Winckelmann (above, n. 26). So far no extant Roman monument of sculpture or painting has been identified with a work mentioned in these sources.

After the first century A.D. Roman literature grows more and more silent about contemporaneous art. Artists' signatures occur not rarely, but, without information about the lives and other exploits of these men, little more than a scanty sociological information can be divined from their mere names. In all essential respects their works remain anonymous art. The underlying sentiment is a critical attitude toward Hellenistic modernism, rather than Greek art as such. For source materials, see H. Jucker, *Vom Verhältnis der Römer zur bildenden Kunst der Griechen* (Frankfort on the Main, 1950), pp. 57 f., 154 ff.

uation. The modern theories considered so far fall in with one of two basic approaches to Roman art. One bases itself on the hypothesis of a national Roman style, the other on the assumption of a continuous evolution of art. One is nationalistic; the other universalistic. In the former group the esthetic evaluation is generally favorable to Roman art. The verdict remains uncertain only with respect to late Roman art. If it is unfavorable, the question follows, what caused the disintegration of the Roman "substance"? In the second group Roman art either appears as the declining stage of Greek art, or it comes to be interpreted as the bridge between Hellenism and the Medieval styles and, consequently, as a progressive development. Again the choice depends on our esthetic judgment. Decline and progress are only two different aspects of the same phenomenon, change, experienced as evolution.

It was necessary to state these differences in order to establish the two categories. Now it must be pointed out, however, that, in addition to the differences which separate them, both categories have an important assumption in common. For both theories aim at a definition of Roman art in terms of a single, distinctive principle. Their quest is either for a permanent principle of style, e.g., spatial representation, as characteristically Roman as groined vaults and pointed arches are Gothic, or for a leading principle of change, to explain the mutation from classical to late classical art. Of this type is Morey's assumption that Roman narrative realism destroyed the classical concept of composition, which possessed unity of time and space. The difference is that one approach requires a

static principle, namely a lasting quality of national character, the other a dynamic principle, that is, a principle in evolution. In both cases theory stipulates a unifying, common denominator of all Roman art, a single "formative will." This being so, it must further be admitted that thus far the study of the monuments has not yielded a stylistic quality as universally and uniquely Roman as required by these theories. Yet, if such a principle were in existence, fifty years of research would probably have succeeded in naming it. Consequently there is every reason to conclude that such singleness of purpose was not the way of Roman art.

Although we reach here only a negative conclusion, it is nonetheless valuable. The very effort spent in these monistic theories without a convincing result makes it likely that their point cannot be proven. Thus in discarding them we really make a significant positive statement as well. If we say that the formative will of Roman art was not unified, we imply that it was diversified. So we begin to examine Roman art from a different viewpoint, looking for its diverse and contrasting aims according to time and circumstance. These aims have yet to be described, but their diversity already appears as something typical of Roman art. Like the assumption of a perennially unified Roman style, the continuous and unified evolution of Roman art reveals itself as a theoretical fiction not consistent with reality. Obviously concepts of this kind had to be invented in order to cope with the vast material, regarding which the Romans left so little documentary evidence. Research only became possible through these auxiliary theories and was constantly

stimulated by their discussion. Yet in retrospect many of these ideas seem a detour, and the necessity of so much theoretical speculation in the literature on Roman art will often be felt as a cumbersome burden.

A remark is due here about the concept of evolution in art. There is no reason why we should assume a logical progress or development in any art. For instance in Egyptian art changes were severely limited by fundamental laws of representation, which remained stable for nearly three thousand years. The changes of style, which nevertheless occurred between the Old Kingdom and the Ptolemys, are not immediately recognized as a consistent evolution. If there is reason to speak of a true evolution in some cases, e.g., in the early Renaissance or in Greek art, these should be regarded as special, because they do not represent a universal rule.

In Greek art, moreover, the evolutionary, that is, logically progressive, character of stylistic changes is more evident in some periods than in others. It is particularly characteristic of the Classical period from the early fifth to the end of the fourth century before Christ. This is the period during which not only the Classical style but also Greek art theory was created. A connection obviously exists between these two facts. The regular and consistent evolution of Greek art during that period did not occur accidentally but as a result of the equally consistent evolution of artistic theory. The artists worked on a limited set of clearly understood and consciously pursued problems of form and of representation; this consistency is reflected in their works. The resulting progress is so precise that by generally accepted archaeological practice undated

works can often be placed within one decade of this evolution on purely stylistic grounds.

Yet during the Hellenistic period the development of Greek art became more irregular as its cultural conditions changed. The competition between the great centers at that time created a pattern of evolution different from the unity of interests and artistic standards which characterized the progress of Classical art. Hellenistic art cannot be so reliably dated to decades, in some cases not even to centuries.

Still less was the even progress of the Greek classicism repeated in Roman art. The aims, the causes, and the pace of stylistic changes in Roman art are much more difficult to determine. For instance, the stylistic differences between the battles of Trajan in the Arch of Constantine and the reliefs of the Ara Pacis Augustae do not impress themselves on the observer as so decisive that they can be named at once. Yet these two monuments originated 125 years apart. On the other hand, if one compares the same battle scenes with those on the Column of Trajan, which are contemporaneous, fundamental differences can immediately be seen. Obviously the pattern of stylistic changes in Roman art is totally different from the Classical Greek. It is neither continuous nor consistent, nor is it calculable as a theoretical, regular progress. Difference of style in undated Roman monuments does not always indicate a difference of time. It is therefore not possible to transfer to Roman art the method, developed in Greek archaeology, of dating monuments by gauging their likely place in a stylistic advance calculated by decades.

This condition must be recognized as symptomatic. It can only mean that certain concepts of evolution which apply to Greek art do not apply to Roman art. Lacking in the latter is the logical and almost rational character of the Greek development, the straight, methodical progress supported by a comparable development in theory. Characteristic of Roman art, rather, is a diversity of standards during one and the same period. Therefore the steps, pauses, and unexpected turns of the evolution of art in Rome cannot be explained by a rational principle; they are not predictable. They must be ascertained in each single instance by factual research and analysis. Only their eventual outcome is securely known, the late Classical style.

Dualistic Theories of Roman Art

On the basis of these conclusions it now becomes possible for us to explain the existence of a third methodological category in the modern literature on Roman art. In this group research is not concerned with the idea of a unified style as something indispensable for the definition of Roman art, nor with the hypothetical principle of a unified and continuous Hellenistic-Roman evolution. Instead, the primary concern of these studies is with the apparent, and sometimes disconcerting, stylistic diversity of the Roman monuments. In this respect, research merely follows practical experience. During the past two or three decades, with the vast increase of knowledge accruing from new and better publications of the monuments, the

importance of this approach has been steadily increasing.[114]

114. Details cannot be enumerated here; for the most recent research, see the bibliography in K. Schefold, *Orient, Hellas und Rom in der archäologischen Forschung seit 1939* (Bern, 1949), pp. 163 ff. Generally characteristic of the latest archaeological research in the field of Roman art is the progress of systematic projects dealing with entire classes of monuments. Important new catalogues of public and private collections have appeared during the past twenty-five years, amongst them the last volumes of E. Espérandieu, *Récueil général des statues et basreliefs de la Gaule romaine*, 13 vols. (Paris, 1907–49), the largest descriptive publication dedicated to Roman art. Another important innovation is the series *Monumenti della pittura antica scoperti in Italia* (Rome, 1936–41) with excellent color reproductions of Roman and Etruscan paintings, which can now be used along with the older publication by P. Herrmann, *Denkmäler der Malerei des Altertums* (continued by R. Herbig) (Munich, 1904–1939).

One characteristic of this stage is the systematic investigation of Roman portraits, private and imperial, as a special group in art (L. Curtius, F. Poulsen). Another is the methodological examination of monuments which are typical of the last centuries of the Empire: sarcophagi (G. Rodenwaldt), late Roman portraits (P. L'Orange), porphyry sculpture and Consular diptychs (R. Delbrueck). An important contribution to knowledge of Roman art was made by the recent monographs on architectural monuments with sculptured decorations in Rome (Arch of Constantine) and abroad (Arch of Galerius, Salonica).

Comparable methodological investigations of whole groups of monuments have been less frequent regarding the early art of Italy and Rome. In spite of all efforts made, this field of research still is handicapped by the fact that too much material has so far remained unpublished or insufficiently accessible. An outstanding recent achievement is the book by J. D. Beazley, *Etruscan Vase-Painting* (Oxford, 1947). Otherwise in this field, also, portraits have lately been in the foreground of interest (G. von Kaschnitz, O.

If one sets out to investigate the stylistic variety of Roman art rather than its stylistic unity, one deals with a set of questions not thus far considered here. The most obvious question is, How many different currents can be recognized in this manner? Most writers in our third category assume a dualism of style in Roman art. It seems to them that, instead of one single style, two different attitudes towards representation have found expression in the works of the Romans. Both attitudes are equally active though frequently in open contrast with each other. The interpretations based on this idea can be classified for the sake of explanation as the dualistic theories of Roman art.

The assumption of a dualistic theory of style raises still other questions no less important. For instance, what are the two trends which we believe present in Roman art? What is their origin? Is their contrast conditioned by definite and still recognizable factors, and, if so, what are these factors? The answers given to these questions differ widely, so widely indeed, that an explanation of the different viewpoints seems here required. Like the two other approaches to Roman art, the dualistic interpretations also involve certain

Vessberg). Much has been done to clarify the chronology of Etruscan painting (F. Messerschmidt) and architectural terra-cottas (E. Van Buren, A. Andrén). An important start has been made in the study of Etruscan sculpture (monograph on the so-called Canopi from Chiusi, by D. Levi, *La Critica d'Arte* 1 (1935–36) : 18 ff., 82 ff.; on Etruscan bronzes, by P. J. Riis, *Tyrrhenika,* Copenhagen, 1941). Together, the mass of material assembled in these recent studies cannot fail at this point to give the study of Roman art a new and more realistic turn.

theoretical conceptions, which must be properly understood. To facilitate their understanding one may say that from this viewpoint Roman art is usually interpreted in one of three different ways. Either its dualism is assumed to be a conflict between rivalling styles, of which sometimes the one, sometimes the other prevails in alternating trends. Or the dualistic character is considered a constitutional trait of Roman art; the trends are parallel, simultaneous, permanently separate. Or thirdly, different modes of representation are employed according to purpose. In that case the trends are not necessarily limited to a dualism, and representational devices are easily transferred from one trend to others as the result of artistic choice. We shall first discuss the genuinely dualistic theories which assume two trends either alternating or running parallel in Roman art. The theories not limited to a dualistic interpretation must be considered separately in the following section.

Obviously in all theories of this type much depends on the definition of the factors which constitute the stylistic diversity or dualism. Furtwängler had already arrived at a dualistic explanation of pre-Roman, "Italic" art. The dualism noticed by him appears in the engraved gems with Latin inscriptions of the third and second centuries B.C. Among these monuments he discovered two currents in mutual opposition, which he called "pro-Etruscan" and "pro-Hellenic." He found that during the first century B.C. their contrast became gradually absorbed by a new style in which the Graecizing element prevailed.[115]

115. A. Furtwängler, *Die antiken Gemmen* (Leipzig and Berlin, 1900), pp. 3, 289 ff.; cf. above, n. 48. The distinction, in the main,

The germ of a dualistic theory can also be found in Wickhoff who thought of Italic art as a style in contrast with the (declining) Greek, with the result, however, that in Flavian illusionism the prevailing Italic element became the driving force of Roman art.[116]

Furtwängler's demonstration relied on his mastery of a vast source material, the engraved gems. He clearly recognized that the two trends observed by him corresponded with two cultural currents of Rome during the Hellenistic period, both equally Roman. His explanation really introduced a dualistic theory of Roman art. Wickhoff, on the other hand, while affirming a similar contrast, recognized only one of the two constituent trends as Italic and Roman. Therefore Sieverking and others who followed Wickhoff arrived at a theory of alternating trends in Roman art, but not really a dualistic theory. They assumed a conflict, not between two Roman currents but between a national and a foreign (Greek) artistic disposition. Thus in Sieveking's hypothetical scheme periods of a national trend in Roman art alternate with others characterized by the allegedly Greek aversion to the representation of space.[117]

Hardly enough attention has yet been paid to a more recent dualistic theory of Roman art briefly outlined some time ago by G. Rodenwaldt. It concerns

is still valid. The question is when and why this dichotomy of trends arose at all in Italian art. See bibliography, below, nn. 120–22 (Kaschnitz). A dualistic theory of early Etruscan art: G. Hanfmann, "The Origin of Etruscan Sculpture," *La Critica d'Arte* 2 (1937) : 158 ff.

116. Above, p. 29.
117. See above, pp. 49–52.

the periodical revivals of classical styles peculiar to the
Roman Empire.[118] In this case the opposing trends are
not identified as Greek versus Roman art but as a clas-
sical tendency in contrast with nonclassical tenden-
cies. Thereby the neoclassic phenomenon comes to be
recognized as a recurrent factor in Roman art with a
significant background in Roman political and social
history. The existence and importance of this factor
cannot be denied. Whenever the classical trend comes
to the fore, a new age thereby defines itself as the res-
toration of a great past. Yet each time the combination
of ancient with more modern elements produces a dif-
ferent result, a new "Renaissance." This happened
during the age of Augustus and again under Hadrian.
Similar conditions led to the revival of both Greek
classical and Augustan neoclassical ideas at the time of
Gallienus, and later still, in more Byzantine forms, to
the so-called Theodosian "Renaissance." The develop-
ment from one revival period to the other was not con-
tinuous; rather, these periods appear as isolated epi-
sodes of reaction to the nonclassical trends that usually
precede them. In this way the history of Roman art as-
sumed its peculiar rhythm. Instead of a continuous
evolution one discovers a progress by alternating
trends related to one another like thesis and an-
tithesis.

The merits of this theory are twofold. It underlines
the importance of the neoclassic movements in Roman

118. G. Rodenwaldt, "Das Problem der Renaissancen," *AA*
(1931) : 318 ff. A similar distinction between alternating neoclassic
and illusionistic periods was adopted by F. Wirth, *Römische Wand-
malerei vom Untergang Pompejis bis ans Ende des dritten Jahrhunderts*
(Berlin, 1936).

art, and it opens a possible access to their historical and psychological explanation. In a wider sense, neoclassic reactions had formed part of Western art ever since the classical style came into being. In Greek art of the fourth century B.C. a tendency to regard certain aspects of the preceding period as classical can already be noticed.[119] This tendency, following a late–Hellenistic impulse, gained full strength in Roman art but did not end with it. The Italian Renaissance of the fifteenth century was only one conspicuous case among many similar, later revivals. The alternation of classical with anticlassical trends remained characteristic of Western thought.

A doubt remains however whether in Roman art each subsequent renaissance can be described as a unified stylistic period. Even during the reign of Augustus not every work of art was equally neoclassic. Classical and less classical periods indeed alternated in Roman art, but the rule of the former was never total. Often the two trends which produced this shift of styles only seem to alternate; they were in fact simultaneous. Also, the nonclassical tendencies presumed by this theory stand in need of a clearer definition. But there is no doubt that the idea of periodical "restorations," meaning a renewal of pristine valor or prosperity or of a golden age, was a genuine and distinctive Roman thought. The ideology of the Empire leaned heavily on it from Augustus to Constantine and beyond.

One point is obvious. The classical revivals are typical of Empire art. Their antecedents in late republican art, if any, are as yet uncertain. But in no way can the

119. Ibid., p. 320. Cf. this writer, *AJA* 53 (1949) : 87.

renaissance concept be valid or helpful in the description of periods which preceded the classical period of Greece. That these renaissances revived already existing classical standards is of their essence. They represent one of the results of Greek classicism, not of Greek art in general.

Yet, in the art of Italy the advent of classicism after the middle of the fifth century before Christ was not the first complicating factor. The dualism of Italian art is older. It has prehistoric roots. All the much discussed contrasts in later Roman art, its antithetical opposites, such as "Etruscan-Hellenistic" (Furtwängler), "Greek-Roman" (Sieveking, Toynbee), "classical-anticlassical" (Rodenwaldt), and others, may well constitute the subsequent disguises or assumed forms of an original split between two artistic temperaments in Italy. In so stating the case we arrive at another interpretation of Roman art, that of G. von Kaschnitz-Weinberg.

This important theory envisages as the essential elements of Italic art two sharply opposed psychological dispositions toward artistic form. When Rome was founded, the contrast betwen these two tendencies was already established. It determined the progress of Roman art through the centuries; perhaps, as a still effective energy, it can be identified in the styles of the Italian Renaissance and Baroque as well. In comparison with this basic, constitutional polarity of Italian art the impulses derived from Greece seem incidental. The art of Italy was always rich in foreign derivatives, but with their help she expressed her own inherent character. We have here another dualistic theory but

not one of alternating trends. The trends are coexistent, parallel, constantly present in Italian art.

As a systematic effort this is probably the most significant contribution since Riegl toward a modern theory of Roman art. However, it is very different from Riegl's own. Kaschnitz started from a limited archaeological problem, namely, early portraits in Italy. His research gradually crystallized into a consistent theory. For a summary at least three of his major publications must be consulted, spanning the time from 1926 to 1949.[120]

Two methodological points must be understood first. One is his concept of "structure," the other, his concept of the regional continuity of Italian art with the resulting emphasis on prehistory as the key to all later art in Italy.

It is not without significance that with Kaschnitz the concept of structure resulted from a study of sculptured monuments. Primarily his theory is one of statuary, unlike that of Riegl, which was a theory of painting and relief. The notions of space, illusionism, etc., are not immediately applicable to solid sculptures, for the description of which different terms are required. *Structure* serves the latter purpose.

As used by Kaschnitz, this term refers to the inter-

120. G. von Kaschnitz-Weinberg, "Studien zur etruskischen und frührömischen Porträtkunst," *RM* 41 (1926) : 133 ff. (in the following cited as "Studien"). Idem, "Bemerkungen zur Struktur der altitalischen Plastik", *StEtr* 3 (1933) : 135 ff. (in the following cited as "Bemerkungen"). Idem, section "Italien mit Sardinien, Sizilien und Malta," in W. Otto and R. Herbig, *Handbuch d. Archaeologie* 6, 4 (Munich, 1950) : 311 ff. (in the following cited as *Handbuch*).

nal (abstract) qualities of style underlying the (representational) surface forms, especially of sculpture. For instance, the famous bronze head called *Brutus* in the Conservatori Palace combines a cubistic and linear principle of design with naturalistic surface forms; the former qualities constitute its structure (Studien, 147 ff.). These stereometrical qualities can be characterized as "static." The structure of other Italic works expresses a different, "dynamic" temperament striving for plastic and rounded, not linear, forms. Instances of the latter category are the Apollo of Veii or, in a later style, certain classes of Etruscan funeral portraits under Hellenistic influence (Bemerkungen, 170 ff.; 186 f.).

These are important statements. They are possible only because in art structure is comparatively independent of representational intentions. Therefore the concept is applicable to all kinds of artefacts, regardless of their purpose and meaning. For the first time by way of this term a theoretical basis was created for the discussion of early Italic sculpture (Bemerkungen, 135 ff.). The two trends of Italic art, according to Kaschnitz, are structural trends, that is, constant attitudes toward form, which must be distinguished from the variable intentions expressed in the various objects of art.

The second thesis of Kaschnitz, the regional continuity of Italian art, followed from this methodological approach. Incommensurable objects like prehistoric vases and Roman portraits become mutually comparable, when their structures are properly analyzed, for structure is a quality of design in objects with and

without representational purpose. Already in the ornamenting habits of primitive artisans during the Late Stone Age a significant dualism can be observed. (Bemerkungen, 143 ff.). This, too, was a contrast of structural tendencies, one dynamic–corporeal, the other geometric–static. It first appeared in central and eastern Europe; the same dual disposition toward form was later inherited by the peoples of Italy.

In its typical Italic form during the Early Iron Age this contrast was incorporated in the two leading styles of central Italy. The plastic–dynamic trend was represented by the forms and dcorations of vessels found in the inhumation tombs (Ital. *fossa*) of Rome, Latium, the Alban and Sabine hills; to these products Kaschnitz refers as the "Alban Fossa–ceramic" (Bemerkungen, 155). The other trend, linear and geometric, characterizes the so-called Villanova civilization, centering in Etruria (Handbuch, 384 f.).

In the area of Rome an earlier population, favoring cremation and geometric–linear forms of decoration, was subsequently invaded by "Fossa" people. Are these the *Latini* and *Sabini* which later united to become the historical Romans? (Bemerkungen, 155 f.). If so, was not by their union the inveterate contrast between static–linear and dynamic–plastic art implanted in the very culture of Rome herself? In this way, Kaschnitz suggests, the evidence gained from the structural analysis of Italic and Roman art can be counterchecked with the findings of Italian prehistory. Imported motive, Oriental and Greek, did not alter the basic structural dualism of art in Italy (Bemerkungen, 164 ff.). They merely forced the native artists to apply

to the representations of man and beast the same contrasting attitudes which had originally developed in the abstract design of primitive crafts.

One may call this a regional theory of Roman art because it emphasizes the lasting identity of trends in a given region, the central-Italian area, of which Rome is a geographical part. In order quite to understand the methodological basis of this theory, however, one other question must be asked. On what actual conditions did the perpetuity of these trends rest? For instance, who transmitted the dynamic style of the potter who formed the protuberances of an Alban Fossa vase to the artist of the Apollo statue from Veii? According to Kaschnitz's theory a supraindividual will expressed itself through the works of these men and thereby perpetuated itself. In terms of a pragmatic history the criticism of this interpretation is not that a transmission of artistic style cannot happen in such a fashion, only that there is so little proof of its actual happening in this concrete instance. At the present moment not much can be known about the transmission of styles—the intellectual working conditions— among artists and craftsmen in early Italy between 800 and 500 B.C. To answer the above question a theory of collective style, i.e., a methodological assumption, must take the place of historical knowledge and documentation.

This assumption with Kaschnitz is the concept of the "formative will," which he accepted from Riegl, and finds expressed in the structures of both abstract and representational art. Similarity of structure in different objects or in whole groups of objects signifies

the action of a supraindividual artistic will, he maintains. The deterministic character of this concept, which we noticed previously, appears clearly in his account of the process of artistic creation (Bemerkungen, 139 ff.).

On the other hand, Kaschnitz does not share Riegl's historical theory of universal evolution. This means that he is not inclined to ascribe a primary importance to the period-styles of art. Rather, he sees a primary condition of art in certain permanent attitudes toward form which remain regionally constant although adapted to changing period-styles. The two trends which he identifies in Italian art seem beyond time and do not really develop. They only change their temporary forms of materialization, so that each time they appear in a different mode of style: Italic and Hellenistic, Renaissance and Baroque, etc. As in the nationalistic theories previously discussed, the assumption is that supraindividual wills create collective styles. The styles, regional with Kaschnitz, are each dominated by a permanent psychological disposition. So the character of Roman Imperial art was predetermined by the two elemental trends which together formed its Italic foundation. Accordingly, in this theory Roman art exhibits a dual nature instead of one single dominant; it possesses two souls instead of one.

This theory makes it possible to combine several observations which in other theories remained incompatible. Thus the two trends of Roman art are conceived as parallel and simultaneous, both equally Italic, although in historical times one has often prevailed over the other. Whenever this happens, the

sequence of styles in Italy assumes the alternative pattern, in which a dynamic period follows a static one and vice-versa (Bemerkungen, 192 ff.).

Likewise, the regional concept implies an aspect of universal history insofar as it deals with the broader circumstances in which Roman art was genetically imbedded. This, with Kaschnitz, is the significance of the term *Italic*. Roman is only a specific variety of Italic art. And the Italic temperament with its specific stylistic tendencies in turn only represents one characteristic manifestation of the still more fundamental Mediterranean substratum, of which Greek art was another conspicuous offspring. In some of his more recent publications Kaschnitz has dealt especially with this aspect of his theory.[121] As in Greece, so in Italy, the Mediterranean substratum with its trend towards objective representation was activated by the "influx of European–Eurasian formative energies" (Handbuch, 386). In Italy the result was the dual nature of Italic art.[122]

121. *Die mittelmeerischen Grundlagen der antiken Kunst* (Frankfort on the Main, 1944). Cf. *RM* 59 (1944) : 89 ff., and below, n. 122.

122. The fact should be mentioned, however, that the two papers cited in the preceding footnote arrive at a somewhat different, rather monistic, conclusion. They deal with architecture, and their purpose is to demonstrate the continuity of Italian art from prehistoric times to the Roman Empire in its spatial, not sculptural, aspect as architecture. From this different starting point the proceed to establish the essential unity of all art in Italy in accordance with a methodological assumption previously formulated by G. Cultrera and others; cf. Kaschnitz, "Bemerkungen," 193 n. 2. In ascribing a continued interest in cavelike interiors to Italian architecture these essays offer a more unified, less dualistic, concept of Italic art.

According to this hypothesis the prehistoric, Mediterranean re-

One remark is due here regarding the method of structural analysis. Avowedly this method aims at describing fundamental, formal qualities of art, reducing to a few essentials the many impressions which we receive from a work of art. Yet in every object the fundamental qualities are also the most general. A cubistic, dynamic or linear quality can be sensed in many different works of art, in many styles. These structural qualities are decisive for the esthetic effect. We may, indeed, accept them as the purest expression of the formative intent, but they are also the qualities most likely to repeat themselves in the human esthetic experience. Therefore geometric styles are common in the world's art, nor can a dynamic form be regarded the exclusive property of any one style. Precisely because they are so fundamental, tendencies of structure can scarcely ever prove a real connection between dis-

ligion of the Earth-Mother and the subterranean womb was the origin of the Italic preference for space-architecture. The domineering memory of these cults was expressed in the survival of primitive architectural forms, like cave-sanctuaries and cavelike tombs. Greek art was from the beginning differently conceived. Its aboriginal forms were the phallic pillar and the upright statue, sculptural symbols of ancestor worship and the divine hero ("Grundlagen," 34 ff.). From the cave-sanctuaries of Malta and similar prehistoric buildings stems the Roman susceptibility to enveloping space. Ultimately, from these memories grew the architectural devices of vault and dome and interior spaces like the Pantheon and the Basilica of Maxentius. This thesis cannot be further discussed here since it is chiefly concerned with the history of architecture and the psychology of architectural forms.

To the above bibliography add now the recent synopsis of these varying observations by the same author, "Über die Grundformen der italisch–römischen Struktur II," *MdI* 3 (1950) : 148 ff.; especially pp. 185 ff.

tant objects, as for instance, between Alban Fossa ce-
ramics and the Apollo from Veii, unless some addi-
tional evidence can be adduced to make this
connection likely.

Obviously a problem of general importance is here
involved. The problem has become urgent, ever since
Riegl expounded his theory that collective formative
wills create and maintain the collective styles of art.
What was that formative will in reality, which created
the collective styles of Egypt, or of the Gothic period,
or of modern art? Clearly a collective formative will is
no more than an abstraction, indeed a myth. A will
can have no impersonal existence. Even a collective
will must be the will of real persons; it expresses their
agreement as to certain standards, for instance, of ar-
tistic representation. These problems were inherent in
the idea of a collective *Kunstwollen* from the outset,
but here they come to a head. In modern art criticism
collective styles are treated as a matter of common ex-
perience. Yet the touchstone of any theory designed to
explain their existence is the question of how the indi-
vidual style of the artist, his personal formative will, is
related to the general style in the realm of actuality.
No theory of a collective Kunstwollen can be more
than a preliminary hypothesis. It will always be neces-
sary to ask for the actual conditions in which alone
a human will can reside, in order to interpret styles
of art. In an archaeological theory which claims the
continued action of prehistoric tendencies in the
art of much later generations this question becomes
particularly urgent. Inevitably, we must ask how the
supraindividual will preserved itself across the centu-
ries, and how it was communicated to the individual
artist.

A collective intent or preference, such as a general taste or will of art, can only reside in an actual group of people. Of what kind, then, are the collective bodies from which emerge the collective styles of art? Two answers, commonly given, were cited previously (pp. 56–57, 97). A collective style can be the artistic expression of an historical period. In this case it represents the will or the aspirations of a section of humanity limited in time, such as one or several generations or ages. The styles in the theory of Kaschnitz are not so defined; they are not period-styles. On the other hand a collective style can be conceived as a traditional vehicle of expression, like a language, proper to an ethnical group. This is the definition of most nationalistic theories and one of the commonest assumptions of prehistoric research.[123] Kaschnitz does not favor the ethnological definition either, although ethnical names are frequent in the prehistoric terminology of which he makes use.[124] This fundamental question thus remains properly unanswered. The very term *Italic*, so important for this theory, conveys no more than a geographical meaning. No single ethnical group corresponds to this name. No element in reality has yet been demonstrated on which to found the suggested unity of prehistoric and historical arts in Italy.

A third answer is possible, however. Art is one among the common activities integrated in the diverse forms of human cultures. If one regards the collective styles as cultural phenomena, one gains a definition which does not bind art to linguistic or ethnical boundaries. Cultural standards often move freely

123. Cf. the statement by F. Matz, quoted above, n. 73; Kaschnitz's "Bemerkungen" frequently refer to this book.
124. "Bemerkungen," p. 151 and elsewhere.

across these boundaries, and it would seem more correct to define collective standards of art—the great "styles"—as an outcome of cultural rather than ethnical conditions. They follow the laws of cultural transmission, which are not the same as those of racial inheritance, and they are largely independent of language, but not of social and cultural circumstances. A cultural definition will likewise make it easier to explain how collective style and individual artistic creation are related to one another within a given area, for cultural standards in the main are voluntarily, and not unconsciously, accepted or changed.[125]

Perhaps the most valuable element in the theory of Kaschnitz will prove to be his methodological tool itself, the structural analysis applied to the anonymous materials of early Italian and Roman art. To analyze a work of art by its structure means to seek objective criteria of description. For this purpose our subjective esthetic preferences are comparatively unessential. In Kaschnitz's definition, the structural analysis of art answers the question, what lies before us and, perhaps, what the artist intended to achieve. The inquiry is limited to the basic, formal properties of an art object. For this reason it must temporarily disregard the other question, how we like what we see.[126] In his analysis of the Brutus—an outstanding example—this method has proved its worth. It will go far to overcome the methodological obstacle which so often arises from the uncertain esthetic evaluation of Roman art.

125. To this aspect of the problem of "style" cf. the interesting remarks made recently by R. Bianchi Bandinelli, Storicità dell'arte classica (Florence, 1950) : xxiii ff.
126. "Bemerkungen," pp. 139 ff.

In the same rubric of theories assuming two parallel trends in Roman art Rodenwaldt must be cited once more. Much of his work was based on a theory of this type, his well-known distinction between "popular" and "great" art in ancient Rome.[127] These categories denote two simultaneous currents of Empire art. The difference between them is not merely one of skill or quality; it involves matters of principle. Great art in Rome always was "fundamentally classical";[128] on this level formed the revivals described above. Popular art, consequently, represents the opposite trend; it was a different kind of Roman art, consistently nonclassical if not consciously anticlassical.

This theory complements that of Kaschnitz insofar as it regards especially the Imperial period; the art of early Italy lies beyond its reach. During the time of the late Republic, a distinctive style of popular art made its appearance on tombstones, funeral altars, and similar monuments. The peculiar realism of the common funeral portraits of the period can be ascribed to this trend. Especially characteristic, however, are certain clearly definable representational devices, which at the same time become frequent in Roman reliefs. Outstanding characteristics of the latter kind, according to Rodenwaldt, are the following: frontal representation of the main personages, symmetrically centralized

127. One finds this contrast pointed out often in his writings on Roman art; see especially G. Rodenwaldt, "Römische Reliefs; Vorstufen zur Spätantike," *JdI* 55 (1940) : 12 ff., and n. 1. The English terms *popular* and *great* art are taken from his chapter on "The Transition to Late-Classical Art," in *CAH* XII (Cambridge, 1939) : 547.

128. *CAH* XII, 546.

compositions, scaling of figures according to impor-
tance (not according to perspective or natural propor-
tion), subordination of environment (e.g., architec-
ture) to the main figures, etc. (Römische Reliefs, 43).
One point is immediately obvious. All the details
named indicate a stylistic tendency which is not only
nonclassical but also antinaturalistic. Classical art gen-
erally avoided these forms of representation. In late
Roman and Byzantine reliefs and paintings, where
they constitute the rule, the same devices were often
ascribed to "Oriental" influences. But this hypothesis
cannot explain the similar deviations from classical
standards in Roman reliefs of the late Republic and
early Empire. Therefore Rodenwaldt concluded that at
least one source of the late Roman style was a genu-
inely Roman trend of art. Gradually this tendency ad-
vanced from the humble status which it first occupied
in Empire art to take its place as a new and generally
acknowledged form of artistic expression. In the pro-
cess were laid the foundations of Byzantine art, which
consequently includes a strong Roman component,
just as Byzantium itself was "new Rome" (Römische
Reliefs, 38 ff).

The distinction between these two trends in Roman
art offers one advantage not found in other dualistic
theories. They can be associated with actual popula-
tion strata. This is the special significance of the term
popular art. By type, purpose, and workmanship the
art created on this level represents a local practice in
Rome and elsewhere serving the needs of the working
middle classes. Therefore its style differs from the in-
ternational classicism of great art. Its language is less
pure and more vernacular. "One might almost call it a

provincial art within Rome itself" (*CAH* XII, 547). The existence of this trend is undeniable and can be understood as a sociological fact.

It is quite another question how these peculiar, nonclassical habits of representation became a popular tradition in Rome. Thus far we have no answer. Rodenwaldt considered the popular style a native trend, which by and by imparted its Romanitas to the higher forms of imperial art (Römische Reliefs, 24). A local and vernacular style it certainly was, but native in the sense of early or intrinsically Roman it cannot be. Its constituent traits are quite precise devices. Some are well known in Egyptian and Oriental art. The advent of Greek art interrupted their use in most countries except Egypt. All of them are absent from classical and Hellenistic Italy. In no way can they form part of a continuous, early Italic tradition. When they finally appear in local Roman reliefs toward the end of the pre-Christian era, they constitute a new kind of primitive art, mixing ancient with novel devices (such as the use of frontality in pictorial composition).[129]

129. Cf. above, pp. 65–66. Rodenwaldt too considered an important innovation the partiality for facing figures evidenced by late Classical paintings and reliefs. He traced the growth of this device both in Western and in Eastern (Parthian) art of the period of the Empire: *BonnJhb* 130 (1928) : 228 ff.; cf. *JdI* 55 (1940) : 38. Because facing seated figures with foreshortened (perspectival) representation of the upper legs appear in Roman art after ca. 270 A.D., he concluded that reliefs showing this type followed a pictorial concept, while earlier Roman reliefs followed a sculptural tradition: *JdI* 51 (1936) : 106.

Against this view see our previous remarks on frontality, above, pp. 65–66. Frontality was not at first a part of the ancient tradition of painting, which, on the contrary, represented figures moving

Pluralistic Theories:
The Inequality of the Contemporaneous

We are nearing the end. Only the most recent set of approaches to Roman art remains to be discussed. They differ from the preceding theories in the following important point.

Artists form the collective styles and conform to them at the same time. Let us resume our previous question. What causes this conformity of form and outlook? And how complete is it at any given time? As we saw, most theories of style since Riegl answered the question implicitly by assuming that historical circumstances, social environment, or biological heritage determine the work of each artist. In any case the range of action is severely limited for the individual. Artists create styles because they cannot work in any other style. There is no freedom, perhaps not even a want of freedom, since no one can look beyond his preordained conditions.

The dualistic theories considered above do not really break with these concepts. It is true that they

and acting sidewise, while it was the rule in the ancient tradition of statuary. Only in the gradual evolution of Greek painting did figures begin to move more freely as if seen from all sides like statues; oblique representations appear. This is the classical stage; it is still reflected in most Roman reliefs before the third century A.D. Finally facing figures became the rule even in painting. The reliefs analyzed by Rodenwaldt, op. cit., do not represent an innovation, in the sense that they were first to follow the rules of pictorial composition. They merely reflect the ancient pictorial tradition in a more advanced stage than did their predecessors.

recognize a dual attitude of style in Roman art instead of complete conformity. Yet they, too, assume in general that an artist adheres to one, and only one, of the two currents which in these theories form the bipolarity of Roman art. In most cases the assumption is made tacitly that an artist by necessity conforms to the style of the ethnical or social group to which he happens to belong; he cannot do otherwise. The possibility is not seriously considered that the same artist may have worked in a dynamic style at one time, in a static style at another, or that under the Empire a single man might work in the popular and the great style with equal facility.

Yet this is precisely the question. Cultural standards are accepted by individual persons for a variety of reasons. No doubt certain civilizations live up to a single formal tradition which constitutes the optimum of art accessible to them. The products of their craftsmen look like mere variations of a common archetype; there is little change of technique, form, or decoration. Conformity to the collective standard is almost complete in these cases and is willingly accepted. The prehistoric civilizations of Italy, including those evidenced by the Villanova and Fossa ceramics, may well have been of this type. But is it likely that the same conditions persisted in the historical periods of Italy and Rome? By then, examples of various standards of art existed side by side within an increasingly integrated community. The provincialism of many regions tended to make the art of Italy more variegated and less concentrated in a single standardizing effort than was the classical art of Greece. Yet these regions were not wholly disconnected; imported art reached

them, and their own products often circulated among their neighbors. And in art, examples not only may be imitated but actually invite imitation by others, as well as rivalry. In short, the conditions of historical Italy developed in such a way that there was every chance for artists to choose at will between various competing traditions. The possibility in Roman art of free exchange and purposeful choice must be seriously considered.

Perhaps it can be said that a degree of freedom, i.e., of choice between conflicting standards, is a characteristic of all art in the higher civilizations. The art of Egypt comprises an important diversity of trends in spite of its seemingly complete unity of style, which first impresses the outsider. Naturalistic and formal trends of sculpture, decorative and abstract concepts of architecture compete with each other and often coexist. Another example, especially informative for the study of Roman art, is found in Assyrian reliefs, where a hieratic style of representation appears coexistent with an entirely different narrative style. These two styles served distinct purposes and were doubtless employed with an awareness of their diversity. For instance, the heraldic compositions of winged genii confronting one another with a sacred tree between them are hieratic. The king's hunt or scenes of war are represented in a much freer style reserved for narratives. This contrast is very similar to the one between the classical (hieratic) style and the so-called folk art (narratives) in Roman art of the Empire. We must conclude that the Assyrian artists were equally fluent in both modes of representation, but that their choice was determined by religious rules and subject

matter. The two trends were consciously employed and distinguished; we may call them "generic styles."

In the light of these considerations it may become necessary for us to reconsider the current conception of "style," in one respect. Certainly the style of a work of art is not entirely the expression of a personal will; it includes impersonal elements. Nor, on the other hand, can it ever be a wholly impersonal performance of a collective will. Between these two extremes it is safe to assume that an artist's work will always be more or less personal according to circumstances. What is a personal element in a work of art and what is not must be determined by criticism. This matter cannot be taken for granted. For instance, there is no reason to assume that an artist cannot employ different modes of representing spatial relations in a painting or relief. The various manners of representing space are teachable devices; they do not necessarily constitute a personal element of style. But neither are they necessarily determined by collective habits. In the nineteenth-century tradition, still valid with us, the habit of a rather photographic rendition of perspective prevails. Yet modern artists for reasons of their own freely employ quite different forms of spatial representation. Again, the question is whether a similar freedom of choice was not enjoyed by Roman artists, and whether our deterministic and evolutionary theories of style do not underrate that freedom.

Particularly, the study of spatial representation in Roman art must lead to this question. For in no other equally fundamental element of representation was the style (the Kunstwollen) of Roman art less uniform.

Under the Empire it appears that the accumulated ex-
periences of the entire preceding art of antiquity, clas-
sical and preclassical, were at the disposal of Roman
artists, and that the artists used these devices, adding
new experiments of their own with considerable free-
dom. The reason was that the Romans did not develop
the conception of a unified space as a general problem
of art. Therefore they felt free to express the human
experience of space in various ways. It is a remarkable
fact that Roman art in the Imperial period did not
adhere to a uniform convention of spatial represen-
tation. Instead, contrasting renditions of space, some
more natural, others more symbolical, are often found
in Roman monuments of the same period, sometimes
even side by side in different portions of a single
monument.[130] In the face of such examples one cannot
doubt the ability of Roman artists to work in different
styles of their choice. Similar observations can be
made with regard to other aspects of Roman art, for
instance, the use of "classical" and "realistic" ap-
proaches in contemporaneous reliefs and portraits. An
interpretation which intends to account for these facts
must resign the idea of an absolute stylistic unity in
Roman art. It must reckon with the simultaneous exis-
tence of contrasting standards and perhaps not only
with a dualism but a plurality of trends. Last but not
least, it must consider the possibility that artists adopt
styles individually, adhere to existing standards by
free choice, and devise means of expression personally
for specific purposes.

The following recent studies in Roman art should be

130. See the remarks about the base of the Column of Antoninus
Pius and similar cases in the paper cited below, n. 131.

read together as representing this point of view; among the modern theories of Roman art they form a group of their own. The present writer first presented a theory along these lines in 1935.[131] Soon afterwards, R. P. Hinks attacked the same methodological problem on somewhat different grounds by describing the forms of spatial representation in Roman reliefs of the Empire.[132] The idea has spread meanwhile. The most comprehensive statement of the problem thus far has come from P. H. von Blanckenhagen, who to the analysis of the Flavian style applied methodological distinctions similar to those previously proposed by this writer.[133] Pertinent remarks can also be found in Rodenwaldt.[134] Most recently, in the same vein, P. G. Hamberg undertook an investigation of the various symbolical and realistic "modes of representation" which were in use simultaneously in the so-called historical reliefs of Imperial art.[135]

Common to all these studies is the emphasis on the essential inequality of contemporaneous products in Roman art. Such is also the attitude of L. Curtius toward Pompeiian painting, which likewise should be

131. O. Brendel, "Gli studi sul rilievo storico romano in Germania" (lecture, March 1935), published in *Gli studi romani nel mondo* 3 (Rome, 1936) : 129 ff.

132. R. Hinks, "Raum und Fläche im spätantiken Relief" (lecture, February 1936), published in *AA* (1936) : 238 ff.

133. P. H. von Blanckenhagen, "Elemente der römischen Kunst am Beispiel des Flavischen Stils," in *Das neue Bild der Antike,* ed. H. Berve, 2 (Leipzig, 1942), pp. 510 ff.

134. Especially *JdI* 55 (1940) : 27 f.; 40 f.

135. P. G. Hamberg, *Studies in Roman Imperial Art, with special reference to the State Reliefs of the Second Century* (Copenhagen, 1945).

recorded in this category.[136] The four styles of wall decoration in Pompeii had since their discovery been regarded as a continuous progress from earlier to later, i.e., more highly developed, forms of art. Only the fourth style realized fully the intrinsic goal of their development, namely, illusionistic representation. Yet, if the third style continued for some time alongside of the fourth, as suggested by Curtius, this idea of an absolute development must be modified. We face then the more complicated case of two parallel trends developing in relation to one another, while their combined evolutions form the development of Pompeiian painting.[137]

The concept of a collective style, inborn to the individual like a character trait, is hardly applicable to any of these observations. The stylistic trends explored in this group of studies appear as comparatively free, perhaps interchangeable, esthetic attitudes and experiments. They developed with the times, yet not without specific reasons. But neither the reasons nor the pace of these stylistic changes are predictable in theory; they can only be described empirically. These trends of style express public aspirations and private sentiments, fluctuations of taste or special interests and dislikes on the part of artists; some are progressive, others provincial and retarding. They appear as pairs of contrast or as multiple currents, parallel or

136. L. Curtius, *Die Wandmalerei Pompejis* (Leipzig, 1929), pp. 198 ff.

137. Discussion of this theory is not yet closed. The earlier theory of a continuous development in Pompeiian wall paintings was recently defended by H. Beyen; see bibliography in K. Schefold, op. cit., above, n. 114, 183.

merging with each other. It is together, in their total-
ity, that they have created what is now known as
Roman art; none is more intrinsically Roman than the
others. Roman art so considered is not a formal style;
rather, it is a general condition of art in historically
definable circumstances. At any rate the feeling pre-
vails, as in the blunt statement by R. P. Hinks, that in
the study of Roman art "the doctrine of a unified
Kunstwollen can no longer be maintained." [138]

The method of these studies aims at descriptive dis-
tinctions. The following are the most important
categories.

1. *Rendition of space* (Brendel, Hinks, Blancken-
hagen). Roman art after Augustus at the latest dis-
played considerable diversity and a rather experi-
mental attitude respecting this problem. Its more
naturalistic forms of spatial representation include the
use of an empirical (not systematic) perspective. Other
devices are decidedly not naturalistic and do not
aspire to a representation of the visual experience of
space. These forms, or rather formulae, of spatial ren-
dition may be called symbolical (Brendel) or abstract
(Blanckenhagen). The contrast between these modes of
representation increased with the times. It already ex-

138. R. Hinks, *AA* (1936) : 248. Likewise, Romanitas can have
no unified content; rather, it consists in a harmony of heteroge-
neous elements. The term is used, redefined in this sense, in Blanc-
kenhagen, op. cit., above, n. 133, 551 ff.; Hamberg, *Studies*, pp.
191 f. On the other hand, while the stylistic inequality of contem-
poraneous works seems the rule in Roman art, the contrasting
"styles" themselves are not absolutely timeless; Roman art is not
beyond all understanding in terms of stylistic periods. On this
point, Blanckenhagen was misunderstood by Hamberg, *Studies*, p.
191.

isted in the reliefs of the Ara Pacis but expressed itself most sharply in the fundamentally different renditions of the enthroned consul and the circus scenes below his feet in late Roman ivory diptychs.

2. *Classical and non-Classical standards* (Brendel, Blanckenhagen, Hamberg). The diversity of spatial representations is closely related to the problem of classical standards in Roman art raised by Rodenwaldt and others. As a rule, the classical style of Greek art favored forms of representation approximating the natural, visual experience of space. Consequently the more "symbolical" renditions of space in Roman art, by contrast, appear non-Classical.

But this is only one aspect of the "classical" problem in Roman art. There are others. It would be difficult in any period to find disparities of style as fundamental as in Roman art sometimes exist in one and the same monument; for instance, in the reliefs decorating the base of the Column of Antoninus in the Vatican. The difference is total, unqualified; its significance can hardly be overstated from the critical point of view. It can, however, be described as the difference between a classical mode of representation and its counterpart, both equally characteristic of Imperial art. In this way we are led to the categories employed by Hamberg. The apotheosis of Antoninus in the front relief of this base is a "classical" allegory.[139] The parades shown on the other sides are composed in a "symbolical" space but otherwise present a realistic narrative; here the difference is one between "allegorical" and "historical" art.

A similar discrepancy exists in the late-Republican

139. Brendel, "Rilievo storico," pp. 134 ff.

FIGURE 7

Relief representing the apotheosis of the emperor Antoninus Pius, from the base of the Column of Antoninus Pius, ca. A.D. 160, Rome, Vatican.

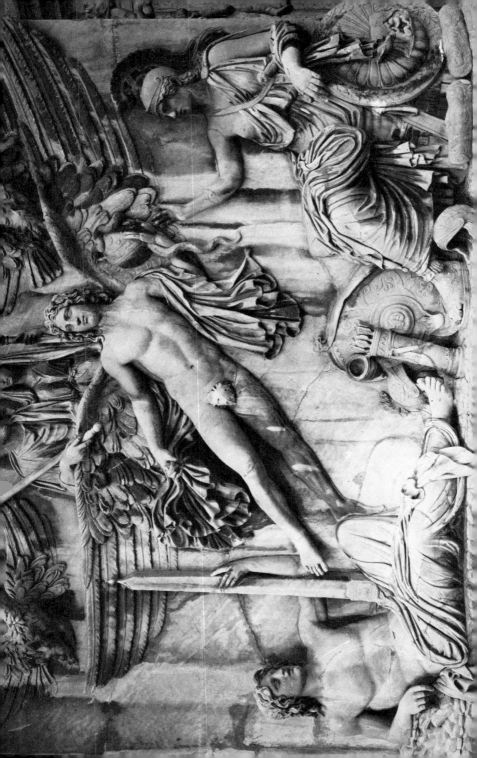

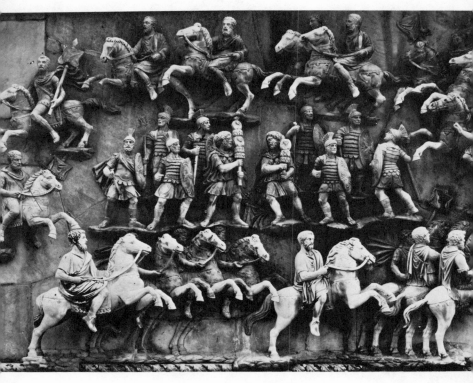

FIGURE 8
*Relief representing a military parade, from the base of the Column of
Antoninus Pius.*

monument of Ahenobarbus. The slabs at Munich with the famous pageant of oceanic monsters represent its "classical" sides; the relief in Paris records the "historical" event which the same monument was expected to commemorate. Again one deals with two entirely different modes—*styles*—of representation. Nor can this contrast be described as popular and great art. The representation of the sacrifice in the Louvre is not popular art. Yet it differs *toto genere* from the mythological compositions which formed its companions.

3. *Generic Styles* (Brendel, Blanckenhagen). The descriptive terms mentioned so far, in this category lead to antithetical pairs of contrast. Thereby they differ from the third concept peculiar to this group of studies, which we here propose to call the principle of generic styles ("autonomia della forma rappresentativa," Brendel; "Gattungsstile," Blanckenhagen). Works of Roman art often conform to certain classifications of type (e.g., tomb reliefs with portraits) or theme (historical narrative), which require different modes of representation. These are "generic" styles. The difference between these styles is comparable to the one between hieratic and realistic reliefs in Assyrian art. However, in Roman art there is no limit to their number.

For instance, the representation of the sacrifice from the monument of Ahenobarbus will be found more similar to other reliefs representing sacrifices than to the mythological compositions which formed its actual companion pieces. This similarity may be ascribed to the generic style common to representations of sacrifices in official Roman monuments. Obviously the generic requirements are often more decisive for the

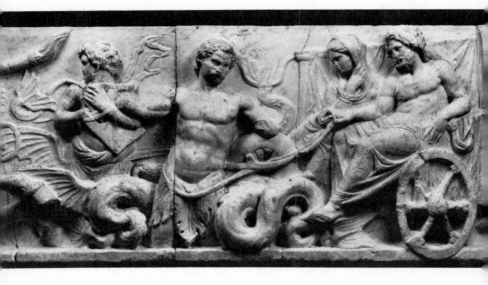

FIGURE 9
*Relief representing marine pageant, from the so-called Altar of
Ahenobarbus (first century* B.C.*), Munich.
(Staatliche Antikensammlungen und Glyptothek)*

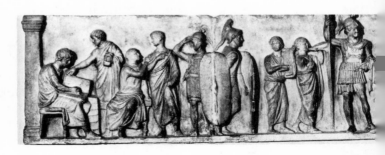

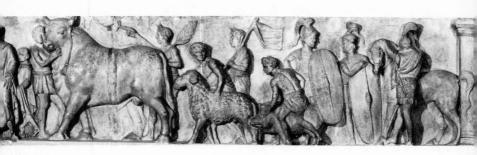

FIGURE 10

Relief representing a Roman sacrificial rite, from the so-called Altar of Ahenobarbus, Paris, Louvre.

composition of a Roman relief or painting than its "period-style."

In many cases the generic style of a certain representation was prescribed, chiefly, by one of those iconographical schemata common in the art of the Empire. A procession on the Column of Trajan may therefore look surprisingly similar to the much earlier processions of the Ara Pacis. On the other hand, not the subject matter alone but also its importance, e.g., in a certain architectural context, often influenced the generic style. In turn, the iconographical schemata develop with the times, as Hamberg has shown (following Lehmann) with the adlocutio scenes in the columns of Trajan and Marcus Aurelius. Even then they remain independent nuclei of composition or autonomous pictures, as it were; one usually recognizes them at once, like a musical motive, in any larger context in which they occur. These iconographical patterns run through all Roman art, like so many independent strands in the complex web of its development.

Whenever this method of investigation is adopted, the lack of stylistic unity in Roman art will seem spectacular. Yet this fact should not surprise us too much. For we ourselves live in a time in which the standards of art are markedly divided. Year after year the most incongruent works of art are simultaneously produced in our world. We have the opportunity at first hand to observe the reactions of a public of contemporaries to such unequal modes of artistic expression. The diversity of possible choices or the lack of unity, which is only the obverse of this condition, must be accepted as the true characteristic of periods like the Roman or like our own. One basic contrast of standards in par-

ticular was the legacy of Rome herself to all later arts. This duality arises from the fact that the classical examples and conceptions can be accepted or declined as standards of artistic creation, but they are not easily forgotten. In this circumstance alone lies a source of possible choices and conflicts not present in any pre-classical art. The Romans were the first to realize and to exemplify this peculiar condition. At least with regard to this unique problem their choice was as free as is ours. Their artistic creations veer toward an attitude of esthetic selection according to taste or purpose, which resembles the postclassical habits of art more than the ancient. In this sense Roman art may well be considered the first "modern" art in history.

II
Roman Art
in Modern Perspective

The distinction between successive and separate stylistic periods, each more or less unified within its proper time and place, provides the working field as well as the primary theory for the history of art as a branch of modern learning. Curiously, in the shaping of this historiographic schema Roman art soon became a touchstone by which to probe the validity of the theory. We may assume that where there is controversy there is a problem: the postulate of an autonomous Roman art, as well as its function within a logically conceived, progressive order of period-styles, proved controversial from the outset. The "Prolegomena" reprinted in this volume were written with this situation in mind, as an outline history of the long-standing debate on Roman art. Their purpose was twofold. By separating the various aspects, approaches, and motivations that came to light in the Roman controversy, one could hope to isolate the problem they have in common; and the future discussion might be freed from the burden of theoretical positions which ought neither to be forgotten nor taken lightly, but must not become a hindrance to a fresh, more direct, and less systematically committed commerce with the monuments.

Since the appearance of my earlier essay a host of new studies have been published. Fresh materials and new thoughts have been placed before us; in this new crop of literature the aims, interests, and points of at-

tack singled out for investigation show significant signs of change. The old battlegrounds of the *ars Romana* today, ca. fifteen years later, are quieter; a great deal of the work accomplished within this span of time turns on examinations of detail, which were sorely lacking during the early stages of the discussion. Conversely, attempts at reviewing the phenomenon of Roman art as a whole, from a bird's-eye view as it were, in order to subsume it to a single systematic heading such as a consistent *Romanitas* of style or some other general principle, have become rare. The few publications that might be so described, but are not yet included with the "Prolegomena," characteristically belong to the beginning rather than to the latest phase of this recent research.[1] Yet, generally, the attention given to Roman art is increasing steadily. The work of the last decade and a half reflects an ever richer picture of the breadth and the variety of that art, though perhaps for this very reason it shows less concern with the overall systems of order so hotly pursued and disputed during the first half of the century.

Nevertheless the problem is still with us, even though at present it may not be mentioned so often. Roman art was the art of a period in time; but it can scarcely be described as the art of a certain people or of a single and one-minded cultural and social tradition. To the large sector of modern thinking which is nationally and ethnically oriented this state of affairs

1. R. Bianchi Bandinelli, *Römische Kunst zwei Generationen nach Wickhoff, Klio* (1960), pp. 267–83. C. C. van Essen, *De kunst van het oude Rome* (The Hague, 1955). H. Kähler, *Wesenszüge der römischen Kunst* (Saarbrücken, 1958).

is apt to appear self-contradictory, irregular, and perhaps even undesirable. In the world of today, social cohesion has long been deemed inseparable from national organization, in thought and in practice; the tendency is still growing to regard cultural phenomena as expressions, primarily, of a national "identity." Yet the Roman world was differently organized, by institutions and ideologies that operated across the national, ethnic, and linguistic diversities of its various populations; the city of Rome, not Italy as a nation, was the hub of this complicated, oecumenic organism. Understandably the modern condition—the only one we really know—raises an obstacle to the comprehension of a meaningful context in Roman art, in its so vaguely delimited fullness. For a proper evaluation of the universalism of the ars Romana—its easy mobility of cultural goods and its tenacious conservatism—our generations lack the commensurate personal experience.

It seems to me that the quest for a workable definition of Roman art as an artistic epoch, and a realistic insight into the makings, the context, and the evolution of that art, is as timely now as it was in the discussions the "Prolegomena" attempted to summarize. The issue that started the debate has not lost its urgency. Yet the approaches to the data at hand, and hence to the underlying problem itself, are clearly changing. New trends of thought and method have already begun to alter our image of Roman art and will undoubtedly alter it further in the years to come. While this current research cannot here be examined in such detail as it deserves I should like to single out,

rather at random, a few points for brief consideration, at the same time apologizing for those others that have to be omitted.

The Range of Roman Art

The range of Roman art is likely to evoke new discussions. I mention this topic first because of its fundamental nature. For any idea that we may form of Roman art and its special character or condition depends on the choice of monuments which we regard as representative. Only the history of architecture, with which I do not intend to deal here, can rely on a fairly comprehensive, staple selection of exemplars that are generally accepted as indispensable for a basic knowledge of the Roman achievement.[2] In sculpture and painting the list of universally recognized—and expected—indispensables is relatively small; too small, in fact, for the monuments so imprinted in the public consciousness to explain and support each other satisfactorily. So it happened that the conventional selections of paragons of Roman representational art have come to look somewhat stale or at least in need of revision and rejuvenation. The recent literature on the subject indicates a strong tendency to enlarge the basis of its discussions by admitting a far greater variety of monuments; in effect, it thus tends to enlarge our conception of the range of Roman art, generally.

The most persuasive witnesses of this tendency to

2. F. E. Brown, *Roman Architecture* (New York, 1961). L. Crema, "L'architettura romana," *Enciclopedia Classica*, vol. 3, 12.1.

present a broader idea of their subject are the new, richly illustrated compendia of Roman art—a gift of modern bookmaking.[3] One only needs to compare recent picture-atlases to the collection of illustrations on which their more modest predecessors were founded: the difference will be seen at a glance. This diversity is not one of numbers alone. More important than the generous increase of illustrations and color plates is the qualitative variety of the selections, which include, together with the standard monuments of Roman official art, an ever larger array of art for private uses: from wall paintings, stucco decorations, and sculpted sarcophagi to minor arts of high quality such as engraved gems, metal armor, furniture, and tableware, or coins; among other changes of esthetic attitude these increasingly liberal selections of samples reflect the growing insight that all industrial art is not necessarily minor. Samples of regional and popular art, which exhibit altogether different levels of quality and style, receive their due, also.[4] New finds from excavations account for only a small portion of this increase. Most of the additional material is drawn from sundry categories of art objects which have been known and studied separately for a long time—some of them for centuries. If until recently these various

3. G. M. A. Hanfmann, *Roman Art* (Greenwich, Ct.: 1964). H. Kähler, *Rom und seine Welt* (Munich, 1958–60). Th. Kraus, ed., *Das römische Weltreich* (*Propyläen Kunstgesch.* 2, West Berlin, 1967).

4. P. Demargne, ed., *Le rayonnement des civilisations grecques et romaines sur les cultures périphériques* (Paris, 1965). O. Doppelfeld et al., *Römer am Rhein* (Cologne, 1967) and *Römer in Rumänien* (Cologne, 1969). J. M. C. Toynbee, *Art in Britain under the Romans* (Oxford, 1964).

monuments were only spottily represented in the general histories of Roman art, the obvious reason was the difficulty of finding a proper place for them within the existing schemata of the presumed order and unity of that art. The dilemma has long been felt: the first important class of monuments that made it evident were the Roman portraits.[5] The more examples of the diverse genres of Roman art are collected between the covers of one book, the more difficult it is to align them sensibly with one another. The impression of diversity prevails; they are not all "Roman" in the same sense, nor by the same characteristics.

The present state of Roman studies requires and encourages a pragmatic examination of special problems. In this task, theory, of whatever kind and persuasion, proves of little help. It may on the contrary appear to be a pleading of special causes or a defense of prejudice, esthetic or national as the case may be. A final synthesis is likely to be postponed, in part because the current prevailing tendency to base the critique of Roman art upon an enlarged and more catholic choice of monuments creates methodological needs of its own. This is the reason why, for a while, the search for the Romanitas of Roman art will probably move into the background, awaiting new answers; if Roman art is to be defined by its extant monuments and not from some preconceived concept, its actual inventory, rather than its innate character, becomes the first matter of discussion. This empirical approach may seem both practical and desirable because it will not hold us

5. R. Bianchi Bandinelli, "Sulla formazione del ritratto romano," in *Archeologia e Cultura* (Milan, 1961), pp. 172–88.

to predetermined generalizations such as the spatial character, realism, or assumed formal proclivities often imputed to Roman art. It must not, however, be expected to lead to altogether easy solutions. The question implied—the extent of Roman art—is not a simple one; it possesses a dual dimension. Understood in the dimension of time, it requires chronological decisions. The possible answers in this direction set the limits of the period-concept "Roman art": When did the hour of Roman art begin and when did it end? If instead the range of Roman art is sounded in depth, the search must take into account all available materials—not only certain types of material—for which chronological simultaneity can be ascertained or made likely. Obviously the chronological question must be answered first. Once a temporal limit has been set—however hypothetically and by whatever criteria—and the attribute "Roman" has become understood as referring, primarily, to the art of a certain time, rather than of a nation, the pragmatic discussion can proceed to the level of descriptive criticism by asking: Of what kind are the various monuments that chronologically qualify as Roman? The same condition applies to the analysis of chronological subdivisions, as for instance Augustan art. The totality of a contemporary output becomes the matter to be examined first; qualitative definitions, by "style" or "intent," follow the period-concept instead of guiding it. The answers to the above question must differ according to the copiousness and quality of the actual art which is found within the—given or stipulated—chronological period. A query so directed must not be

selective from the outset; or rather that chronological coincidence provides the sole reason, in principle, for selecting the objects submitted for discussion.

Chronological Limitation

There never was much doubt that the bulk of Roman art hails from the period of the Empire. Uncertainties arise about the fringes, however, on either end of that core period. Roman art disengaged itself with remarkable slowness from the surrounding, Greco-Italic tradition in which it was imbedded; and it disappeared equally slowly in the mainstream of the incipient Middle Ages. Its borders are blurred, both at the beginning and the end of its long history. In setting their limits, a degree of arbitrariness seems unavoidable.

To this day most histories of Roman art set out from the Capitoline wolf (fig. 11), which indeed may be the first significant work of art extant, made for Rome and in Rome. Apparently it is one of the earliest, large hollow-cast bronzes preserved from the ancient world. But in what sense is it Roman art? Not even its subject, the maternal wolf, belongs to Roman legend alone. On the evidence of style the wolf is probably best described as the outcome of an Etruscan tradition in a late-archaic manner, transplanted to Rome. Whether from this proud and lonely work a genetic bond leads to the documented Roman art of later periods remains a moot question.[6] Not that such a

6. O. J. Brendel, *Etruscan Art* (Pelican History of Art, Harmondsworth, 1979). While writing "Roman Art in Modern Perspective" the author worked on his book on Etruscan art. (Ed.)

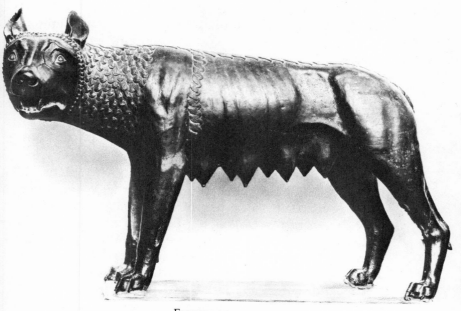

FIGURE 11
Capitoline wolf, Rome, Museo dei Conservatori.

connection is totally unlikely; it is difficult to demon-
strate, however, owing to the equalizing effect of the
Hellenization which all art in Italy underwent from the
close of the fourth century B.C. Actually, at present,
coherent accounts of Roman art start usually from a
much later date—hardly before the middle of the sec-
ond century B.C. This, of course, constitutes a practical
decision, based on empirical grounds alone: there
simply is no body of material sufficient in number and
characteristic quality on which to build a plausible
history of Roman art before the Punic Wars. Even
when, eventually, a Roman offshoot makes its appear-
ance, between the Hellenistic-Etruscan and the Greek-
Hellenistic branches, its first recognizable symptoms
were Latin contents, not a particular formal style. The
silence of the monuments is hardly fortuitous.

The quest for a pre-Hellenistic Roman art now
seems to hold little promise: early Rome was a prov-
ince of the Etruscan-Italian community culturally, and
so was her art. For the same reason, however, it does
not seem advisable to think of the later Roman art,
which we know better, as an event wholly separate
from the Italic tradition wherein it came to pass.
Rather, it ought to be understood as the end phase of
that tradition, both chronologically and by intellectual
inclination. Faced with the array of choices which the
post-Hellenistic world offered, the creators of the ris-
ing Roman art felt as little committed to a single rule
of form as did their Etruscan forbears. Like most ear-
lier art in Italy their work was a response to current
demands and to art already in existence. Occasionally
this variousness may have included formal preferences
transmitted through occult channels from the native

past of the region. If so, the impact of such distant reminiscences could only have been a limited one, and never general. The Italic heritage of mature Roman art may more likely be found in its capacity to grow and expand, not from a single root like a plant but by accretion; by a consistent adaptation of the new to the old and of the foreign to the domestic; by a singular talent to live up to the hopes and the needs of each changing day.

Equally debatable as the point of departure is the terminal date of the period of art to which we attach the Roman name. The uncertainty, at this point, does not come from lack of material but from the gradual pace of the transition that joins the late Roman with the ensuing Byzantine and early medieval arts. In recent studies one finds a marked tendency to set the limits of Roman art at some time beyond the reign of Constantine, which formerly most often served as the symbolical terminus of the latter. The contention that in fact Roman art extended beyond this date has significant implications. It subordinates the differences of religious themes and ideology, that separate the early Christian from pagan monuments, to a visible continuity of styles which are common to both.[7] It disregards the political changes that separate the Roman principate from the Byzantine and medieval interpretations of the monarchy, for similar reasons. Therefore, in justice to the argument of artistic criticism, it becomes necessary to settle on a new date—one per-

7. F. Gerke, *Spätantike und frühes Christentum* (Baden-Baden, 1967). A. Grabar, *Early Christian Art* (New York, 1968). A. Rumpf, *Stilphasen der spätantiken Kunst* (Cologne, 1957). W. F. Volbach, *Early Christian Art* (New York, 1962).

haps equally symbolical but more in keeping with the monuments—for the assumed final border of Roman art. The suggestion made some time ago by G. Rodenwaldt to understand all late Roman art as continuous until the time of Justinian I—that is to say, to the middle of the sixth century A.D.—may yet carry the day.[8] At any rate the paradox is already apparent that the histories of the Roman state and of Roman art do not coincide chronologically. On the testimony of its surviving remnants the period of Roman art started at a conspicuously late date in the continuous expansion of the state; and it outlasted for more than two centuries the Roman Empire in its canonical form, as an undivided polity.

Roman Art Considered by Categories

The range in depth, as I called it here, poses the peculiar problem (p. 145) of the qualitative diversity which is often observable in the various strata of Roman art, among objects of the same age. Ever since the epochal divisions of art were recognized as historical units, it seemed self-understood that the artifacts of a certain period were coequal stylistically, and therefore had to be subsumed under a common heading. Vase-paintings and popular terra-cotta statuettes of the fifth century B.C. are no less Greek than the Parthenon; illuminated manuscripts and stained glass windows of the thirteenth century are no less Gothic than the architecture of Chartres. In Roman art, how-

8. G. Rodenwaldt, "Zur Begrenzung und Gliederung der Spätantike", *JdI* 59/60 (1944/45) : 81–87.

ever, the disparity of "generic styles," developed and maintained for special themes and uses, is often more apparent than their unity.[9] Since the need of a synoptic view that is capable of encompassing the true manifoldness of the available materials is now growingly felt, it is likely that in the future our ideas about Roman art will change considerably. Already appearing is at least one significant result of the catholicity practiced in the widening selection of objects which are gathered in recent studies: any approach that addresses itself to the entire stock of Roman art, in all its manifestations and regardless of their quality, content, or purpose, is bound to isolate the official art of Rome as one special class only within the total production. Yet from the start the modern accounts of Roman art relied on these official testimonies almost exclusively, by singling out for discussion, first of all, the political monuments made for the public eye. From the study of these monuments and that of portraiture derived most current opinions about Roman art. Obviously the task now before us will be, in a critique of Roman art as a whole, to restore the balance which must have once existed between the public and the private sector.

Public Art

The public monuments and the imagery of which they became the principal carriers—the altars, triumphal

9. F. Coarelli, "L'ara di Domizio Enobarbo e la cultura artistica in Roma nel II sec. A.D.," in *Dialoghi di Archeologia*, vol. 3 (1968), pp. 1ff.

arches, pictured columns erected in the city, in Italy, and in the provinces—will probably always furnish the core material on which to build the history of Roman art; they will also provide its chronological backbone. There are several reasons why they should retain this place of prominence. Their number includes the most obvious and accomplished commemorations, in art, of Roman events and thought. Their themes, being Roman-political, often lay beyond the inherited Greek iconography, and hence gave rise to new representational traditions. Also, the official monuments constitute by far the most continuous and coherent branch of all Roman art. As datings by style alone are notoriously precarious in this area, the chronological order of the anonymous artistic relics that form the great bulk of the Roman private art must depend entirely on comparisons between otherwise undated works and the more or less accurately datable official architecture, reliefs, portrait statues, or portraiture on coins identified by legends. Indeed, some of the most successful recent forays into the *terra incognita* of Roman art are studies tracing particular religious or political themes such as the representations of public sacrifices [10] or of military trophies [11] throughout their long histories. It seems an interesting by-effect of these studies that each leads to a slightly different periodization of the whole field, according to its proper theme.[12] In the mirror of its public manifes-

10. I. Scott Ryberg, "Rites of the State Religion in Roman Art," *MAAR* 22 (1955) : 1–227.

11. G. Ch. Picard, *Les trophées romains* (Paris, 1957).

12. O. J. Brendel, review of Picard, *Les trophées romains, Gnomon* 36 (1964) : 498–508.

tations the Roman appears very much a thematic art.

It becomes ever clearer, however, that in the whole texture of Roman art the official monuments form a particular strand, limited in scope and means of expression. Roman history is primarily the history of the Roman institutions; and what now is often, if hardly quite properly called Roman "historical reliefs," chiefly deals with the vicissitudes—the changing conceptions and functions—of these institutions. The mass of private art shows few if any obvious contacts with the official. Only one ruling trend is common to both: the prevalence of pictorial representations, including reliefs, over statuary. In the private sector political subjects are extremely rare. The preferred themes are idyllic: landscapes and still lifes, religious ceremonies, mythological or legendary narratives, and family portraits. With the progress of time one observes fluctuations of emphasis among these several topics, especially from the second century onward, when a new funerary element appears in the sculpted sarcophagi. Even then the mythical, religious, and literary illustrations retained their former popularity, though they persisted alongside of new topics such as a man's career in public office or the favorite circus races; all endowed with new connotations of meaning. The point is that in Roman art, as in Roman juridical thought, a fundamental division existed between a *res publica* and a *res privata*. As either province of the common social order possessed its own store of themes, mythologies, and ideologies, which each demanded its proper modes of expression, the arts provided different traditions, iconographies, and styles for either area. The split, it seems by comparison with

other times and peoples, was typically Roman. But so were the two kinds of art themselves which followed from this dualism—one serving the needs of the state and the other the spheres of private concern. The public and the private art of Rome ought to be considered the two sides of an identical historical situation that produced them both. To think of one as more Roman than the other, a priori, can only impede the understanding of either.

The Greek Element

The Greek element in Roman art still presents a major obstacle to the plausible exposition of this unity.[13] It is in fact ubiquitous and must be regarded an integral, perhaps even regulative, factor in most Roman art ranging from architecture and representations of the human form to ornament and utensils. But the density, import, and obviousness of its presence differ greatly from one monument to another, and from one class of monuments to another. An air of candid Hellenism is more typical of private art (fig. 12); while in the public monuments the obvious Hellenisms are rarer, and the total effect is likely to diverge substantially from genuine Greek art, either Classical or Hellenistic (see fig. 5). For this reason the official art may often, at a glance, look more "Roman" than would for instance be true of the domestic wall paintings or of decorated silverware. On similar grounds other special classes of representational art, such as the staid and

13. G. Traversari, *Aspetti formali della scultura neoclassica a Roma dal I al III sec. d. C.* (Rome, 1968).

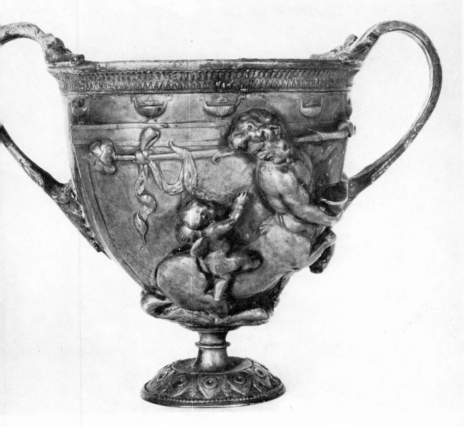

FIGURE 12

Roman silver cup (first century A.D.*), an example of private art,
Naples, Museo Nazionale.*

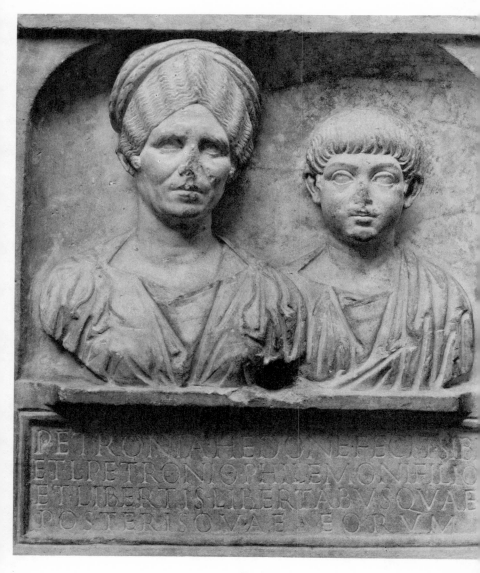

FIGURE 13

Tombstone of Petronia Hedone and her son, Lucius Petronius Philemon.

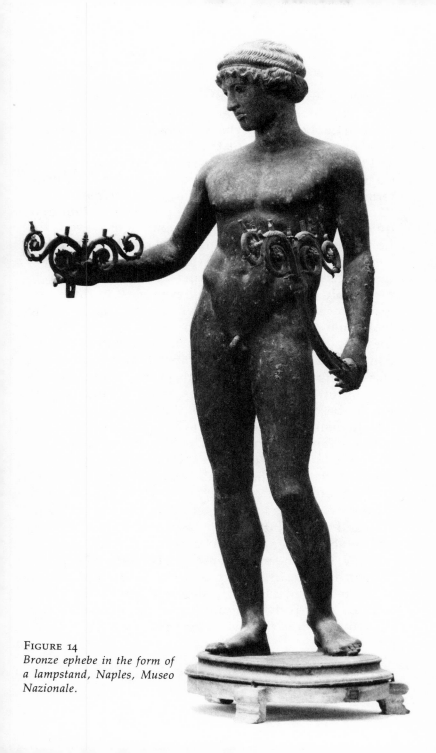

FIGURE 14
*Bronze ephebe in the form of
a lampstand, Naples, Museo
Nazionale.*

homely household portraits (fig. 13) or the manner-
isms of certain "popular" styles, promise to yield
more reliably Roman characteristics than the objects
that reflect the tastes of the educated middle classes
and the affluent (fig. 14). Yet on the whole, the present
stage of the discussion does not encourage such neat,
terminological distinctions between "Greek" and
"Roman," understood as two opposing and definitive
qualities of art. In the official monuments, even, the
Roman quality usually admits Greek components; for
instance the representations of the imperial triumph
often include Grecian-looking personifications, to
name only one of the simplest examples. In their con-
text, however, these semimythical fancies cease to
look truly Greek. They are no longer Greek art; one
may say that they have assumed a Roman hue. This
condition even attaches to compositions in which the
classicizing allegories are much in the majority, as in
the "Apotheosis of Antoninus and Faustina" carved
on the base of the Column of Antoninus (see fig. 7).
The Roman component, far from excluding the Greek,
includes and confirms it. Thereby from monuments
such as these, the Roman denominator emerges as the
higher order, in effect: it absorbs and transmutes the
subordinate order, namely, the Hellenizing detail.
Evidently it is the former agent that demands explana-
tion and a more intimate analysis; it does not reside in
the subject matter alone. As becomes ever more appar-
ent the relation and interaction between Greek and
Roman factors, in the actual work of art, produce an
intricate union. One may doubt if either factor will
ever be effectively extricated from the narrow texture
of which both partake. The time may have come when

we ought to base the question of Romanness on a different set of assumptions. If the acceptance and absorption of a Greek component constitutes its most widely attested characteristic, as seems to be the case, then the history of Roman art can be no other than the history of that fusion itself in its varying forms, degrees, and successive stages. It is clear that in this process the old-Roman, or ancient Italic, components lost much of their original individuality; but so did the Greek.

After the second century B.C., when Rome fell heir to the Hellenic civilization, Greek art began to exist in a different climate of opinion. More and more the esteem which it continued to enjoy rested on past achievements: its ancient exemplars, precepts, and the richness of its imagery. There was, of course, for a long time to come, contemporary art made by Greeks abroad and in Greek lands. This contemporary production, however, though often of high quality, soon ceased to lead the trends of change; nor did it maintain a power of growth recognizably its own. Instead it followed the evolutional dynamics of the new common art, which was precisely the art now called Roman. It no longer functioned as a central force that might generate, rally, and radiate its proper energies. During the centuries of this evolution we find both Greek and Roman elements in constant interaction, but in a state of flux rather than stability: both were subjected to the same forces of change which led the Roman oecumene in its entirety, regardless of its internal ethic or linguistic boundaries, from its Hellenistic start to its final, late-Roman condition.

Painting

Roman paintings deal but rarely with political themes
and the state religion; the few examples still extant are
of late-Roman date.[14] Yet such monuments existed.
There is reason to believe that, if more were pre-
served, the gap between painting and official art
would turn out considerably less than appears at
present. As matters now stand the political art of
Rome is almost exclusively represented by reliefs and
sculpted portraits. Vice versa, almost all surviving
paintings are in the category of private art, designed
either for dwellings or for funerary purposes—two
genres that admit political themes only on the rarest
occasions. The official topics required illustration of
contemporary detail, in a special style of public
address that combined realism with gravity. How the
paintings may have looked which aspired to the same
manner of style—the painted counterparts of the sol-
emn reliefs—we hardly know. Most paintings which
we can still consult illustrate mythology (fig. 15), acts
and symbols of private religion such as the Dionysiac
(fig. 16), or the noble pleasures of rural retreat: scen-
ery, gardens, kitchen still lifes (figs. 17, 18, 19).
Judged by their themes the private genre of painting
and the state reliefs are incommensurable objects.
Moreover the diversity of subjects often impedes the
comparison by style, also, between the members of
two groups so contrasting. Accepting this condition,

14. M. Cagiano de Azevedo, "La Dea Barberini," *RivIstArch* 3 :
108–41.

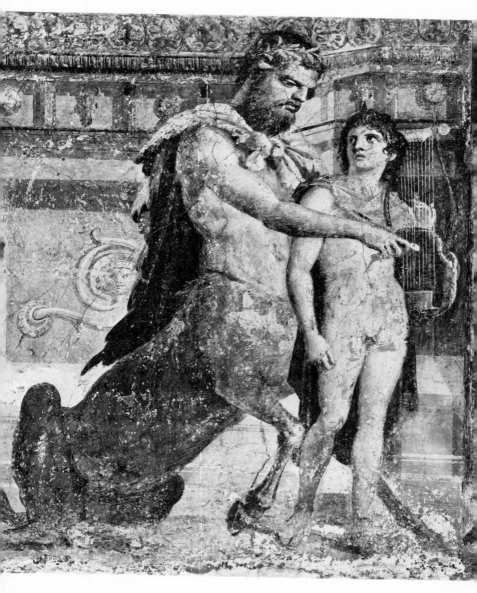

FIGURE 15
Chiron teaching the lyre to Achilles, Naples, Museo Nazionale.

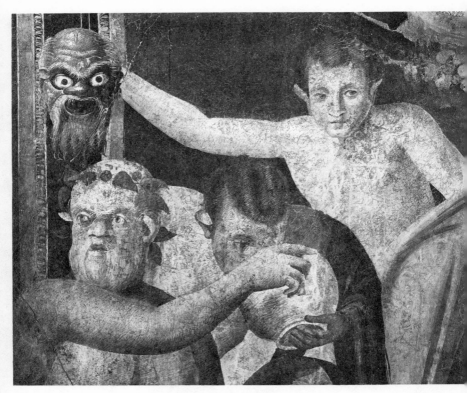

FIGURE 16
Detail from the Dionysiac frieze, Villa of the Mysteries, Pompeii.

FIGURE 17
Detail of wall painting from the cubiculum of a villa at
Boscoreale (first century B.C.).

FIGURE 18
Detail of frescoes from the Villa di Livia, Rome, Museo Nazionale delle Terme.

FIGURE 19
Kitchen still life, Naples, Museo Nazionale.

at least temporarily, we must however note the superiority in numbers of the civil over the public art. The comparative copiousness of paintings preserved from private houses or burials persuasively argues the limited scope of the public monuments, however highly we esteem the import of the latter. One other remark follows from these premises. Not only is the private sector of Roman art the more numerous by far; it also is the one more varied. For its spread and, indeed, for its every existence it must be held an essential—not merely marginal—factor of the cultural life in ancient Rome. Therefore the apolitical art ought not to be regarded less typically Roman nor less representative of the Roman genius than the public art which represented the domains of state and government. The chief difference lay in the special mode of representation that was reserved for the latter, in accordance with its declared purpose as a visual record of actual events and of their official interpretation: its tenor was factual, historical, and proclamatory.

Recent research strengthens the above observations in several respects. Although the preserved paintings reflect on the whole the tastes and cultivation of private people, they nevertheless promise an effective contribution, not yet sufficiently explored, to the critique of the whole of Roman art. For instance, they may shed light on the otherwise obscure process by which Roman art detached itself from the late-Hellenistic. The transition apparently was gradual; it seems that we still can follow one of its aspects, in the development of the painted and stuccoed wall decorations. In the history of painting these decorations constitute a particular class, both for their technique and

their purpose, which was chiefly confined to architectural interiors; the representations which they regularly contained in their advanced stages came into being as an adjunct of the decorative systems known at present as the four "styles" of Romano-Campanian wall painting. Yet the first of these four successive stages, the main feature of which was the imitation of masonry and ashlars, certainly followed a common, Pan-Hellenistic fashion of wall decoration, with antecedents reaching far back into Greek classical architecture. Traces of decorations in this manner have appeared in different parts of the Hellenistic world. Evidently the international fashion was received with eagerness in Roman Italy, where most of the surviving examples are now found (fig. 20), both in public buildings and in many private dwellings. Therefore the collected topographical evidence as well as the formal characteristics of the Romano-Campanian "First style" strongly suggest that this mode of architectural decoration did not start as a manifestation of Roman art, in any sense, though it may well have ended as a Roman style. Certainly it became the point of departure of the long series of Roman painted wall decorations based on architectural motifs. From then on, the rapid development of elaborately painted room decorations, including large and small figural representations, sham architectures, and feigned vistas, became a specialty of Italian domestic architecture. Already the second style of Romano-Campanian painting may confidently be called Roman art (fig. 21). By that time, at the latest, the evolutional momentum had moved to the West.

We may read the particular history of this stylistic

FIGURE 20
First style wall decoration in the entrance hall (second century B.C.*),
Samnite House, Herculaneum.*

FIGURE 21
*Second style wall painting in the Villa of the Mysteries (first
century* B.C.*), Pompeii.*

migration as a paradigm of the far more inclusive transfer from the eastern Aegean to Rome of the center toward which the cultural universe of the ancient oecumene gravitated. According to this limited model the change from "Hellenistic" to "Roman" art also did not happen suddenly. A considerable span of time—perhaps more than a century—must be assigned to it. One should note, moreover, that in this instance a development which occurred in the sector of private art also has a bearing on the periodization of Roman art as a whole. The third Romano-Campanian style was characteristically late-Augustan. Its wall decorations shared with the political art of their time the partiality for neat planes, low relief, and gemlike outlines—in short, all the symptoms of that Latin redefinition of the Classical which accompanied the Augustan reorganization of the res publica (fig. 22). For a full description of this period the private monuments, including the reliefs in silver vessels, cameos, and especially the painted walls, are indispensable.

Perhaps in consequence of this historic shift which sealed its past and determined its future, Roman painting through the centuries gives a consistently more Hellenizing impression than other branches of Roman art. Yet to assess justly the Greek element in it still poses a difficult task. For in this complex situation the Greek factor may show its presence in different ways and act in different functions. In certain respects it can be evaluated as a straight survival—a result of cultural or professional continuity—owing to the gradual change of emphasis from Hellenistic to Roman. Painting techniques and media, which in retrospect appear decidedly Roman, may actually have been

FIGURE 22
Stucco decoration from a Pompeiian wall (first century A.D.), Naples, Museo Nazionale.

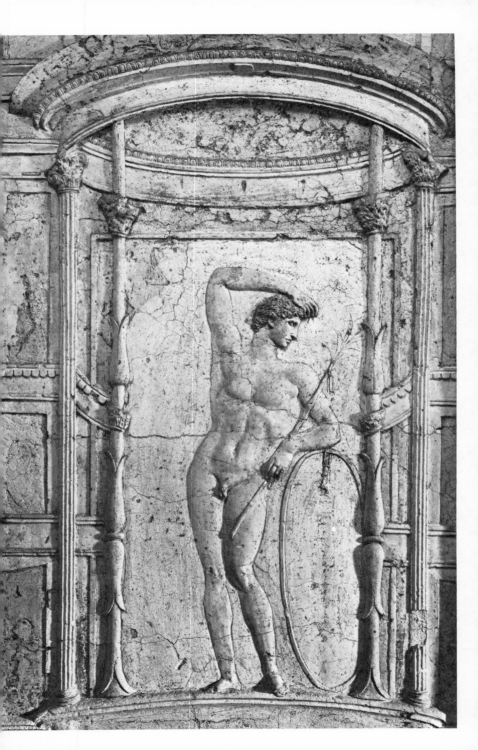

legacies of the past, or developed during the time of transfer from East to West. Thus the skill to paint on levigate gypsum surfaces is most abundantly documented in the decorated houses of Rome and Roman Campania, but decorations painted in similar media are now also known from houses in Delos and other Hellenistic sites.[15] The chances are that this technique was an innovation of the second century B.C., about contemporary with the invention of mosaics composed of very small tesserae.[16] Both crafts seem to have reached Campania and Rome almost immediately after their invention, together with the "masonry-style" of stuccoed wall decoration.

A significant Greek inheritance in Roman painting was the contrast between a draftsmanlike method of representation by clear outlines, combined with crosshatching when an effect of shading was intended; and a painterly, pseudoimpressionistic manner that built the formal likenesses of things from tones of color and the stark opposition of light and dark patches, using a minimum of line (fig. 23). The dichotomy was one of long standing. Its roots lay in Greek art around 400 B.C., as we know from the disputes about the relative merits of the painter Apollodoros the Skiagraphos on the one side and the linearist Parrhasios on the

15. M. Borda, *La pittura romana* (Milan, 1958), pp. 5–18. V. J. Bruno, "Antecedents of the Pompeian First Style," *AJA* 73 (1969) : 305–17.

16. K. Parlasca, "Das pergamenische Taubenmosaik und der sogenannte Nestor-Becher," *Jdl* 78 (1963) : 256–93. K. M. Phillips, "Subject and Technique in Hellenistic-Roman Mosaics: A Ganymede Mosaic from Sicily," *ArtB* 42 (1960) : 241–62.

FIGURE 23
Wall painting from Pompeii: Ulysses disguised as a beggar surprising
Penelope (first century A.D.*), Naples, Museo Nazionale.*

other.[17] "Illusionism" of any kind, whether by this term one understands coloristic, spatial effects or a painterly pseudoimpressionism, ought not be regarded a novelty in Roman times, let alone a Roman innovation. It was neither more nor less Roman than its counterpart, representation within firmly drawn contours. The distinction between these alternatives, as two choices immanent in the painter's craft, had originated in Greek Classical art; it remained in force through the Roman period. The same contrast is still clearly noticeable among the latest, large group of ancient paintings, the sketchily decorated walls and ceilings in Roman catacombs of the third and fourth centuries A.D. (fig. 24).[18] The Italian Renaissance revived the classical argument in the rivalry between Florentine *disegno* and Venetian painting, and thus handed it on to the moderns.

Nor was this persistence of tradition, from the classical or Hellenistic into the Roman period, limited to painting methods and media. A similarly evolutional, rather than static, continuity connected many characteristic themes of Roman painting with Hellenistic origins. The latter observation applies especially to the thematic repertory of the four styles, which for all its richness remained quite homogeneous until A.D. 79. It can now be considered certain that still life painting became an accepted subject of art in the Hellenistic period though the Roman painters seem to have surpassed their Greek forbears in the variety of arrange-

17. J. J. Pollitt, *The Art of Greece* (Englewood Cliffs, N.J., 1965), pp. xii, 111–12, 158–61.
18. Grabar, *Early Christian Art.*

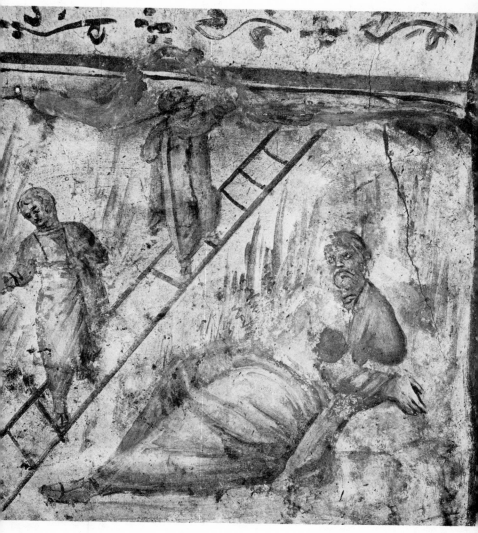

FIGURE 24
Jacob's vision at Bethel (fourth century), catacomb in the Via Latina.

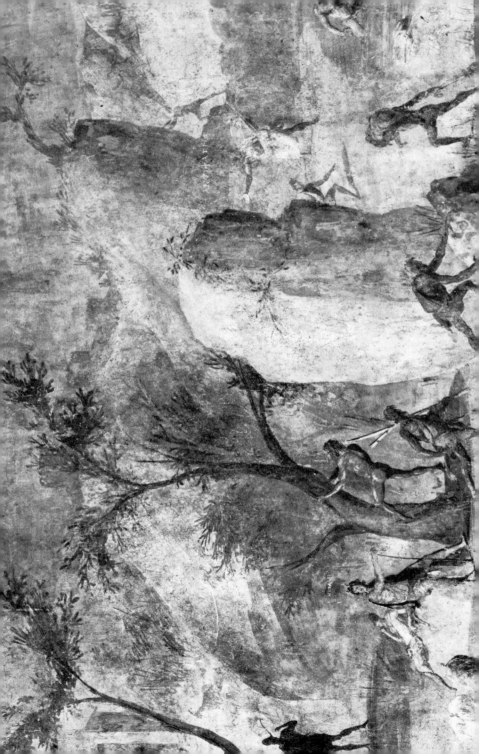

ments.[19] The origin of landscapes as a pictorial subject by itself, unrelated to human action or narratives, is not equally certain. One of its sources may be backdrops for the theatrical stage where the actors supplied the human element and where the painted surroundings could therefore represent unpopulated architecture or scenery.[20] To this day, however, no Greek antecedents of pure landscape painting have been forthcoming. Thus far the sceneries preserved on Roman walls of the second style (fig 25) have retained their place as the first painted testimonies in history of that visual delight which the mind may derive from the still settings of nature.

Copy and Variation

The human theme, by contrast, usually called for action between two or more persons or at least a situation of converse. In the paintings of the second style the human subjects began to lead all others. Their frequency increased fast after the middle of the first century B.C., when wall decorations tended to become the ornate settings of separate painted compositions, enclosed by framing lines. The great majority of these paintings represented Greek myths; hence, in Roman art, they formed an indubitable Grecism, though one

19. J. M. Croisille, *Les natures mortes campaniennes* (Brussels, 1965).

20. C. Alexander and P. H. von Blanckenhagen, *The Paintings from Boscotrecase* (Heidelberg, 1962). Vitruvius, *De arch.* 7.5.1. J. J. Pollitt, *The Art of Rome, c. 753 B.C.–337 A.D.* (Englewood Cliffs, N.J., 1966), pp. 127 ff.

FIGURE 25
Panel from the Odyssey landscapes (first century B.C.*),*
Vatican Museums.

of a special sort. In the intellectual establishment of
their time they occupied a place not unlike the clas-
sical mythologies in Renaissance and Baroque art. To
the educated, the very foreignness of this imagery be-
came a mirror of human destiny which the past held
up to the present: the message of the myth came from
beyond the bounds of the contemporary society. In-
sofar, however, as the Greek histories in the Pom-
peiian paintings fulfilled a similar function, they must
be counted as a phenomenon within the Roman con-
temporary horizon, by effect if not by origin. In this
respect they do not differ much from other Greek ele-
ments absorbed or assimilated by the literate Romans.
But the Greek iconography in which they were vested
poses questions of another sort. For what reason and
in what manner were these ancient themes and image-
types transmitted from their supposed places of origin
to their Roman settings? At present these are un-
decided questions. The most frequently suggested an-
swer, to consider them as copies of lost Greek origi-
nals, can hardly be said to have proved persuasive in
many instances. Lack of tangible evidence is not the
sole reason. Another considerable difficulty arises
from the paintings themselves, which often present a
rather un-Greek look as a whole, even when reminis-
cences of earlier Greek art can be spotted in them. It is
not unlikely that copies of famous prototypes should
be found among the Roman paintings, since copying
was demonstrably practiced in Roman sculpture. The
ultimate difficulty stems from our inability to distin-
guish with any degree of certainty between copies in-
tended to be precisely that, namely, true and as far as
possible complete imitations of an individual *opus no-*

bile; and other, looser methods of iconographic transfer, from one place to another and from one medium to another.

It seems to me that the present state of research makes it advisable to employ the term *copy* sparingly in regard to the extant Roman paintings. Some can be so identified with reasonable probability. The majority appear to belong to other categories, on a level midway between copy and originality. The often observed "variations" of a certain representational schema really beg the question: there obviously is a substantial difference between copy and variation, though this may not always be sufficiently heeded. A painting, it would seem, can only be copied in the presence of the original or at least of another copy sufficiently faithful to render the details of both design and color. Variations can be produced by much more flexible methods, from prototypes twice and thrice removed from the original that started the series. They may be due, for instance, to transportable aids such as sketches in pictured scrolls kept in the workshops as model books. A recent, painstaking investigation of a particular mythical theme, the "Fall of Icarus," in paintings from Pompeii rendered results which, rather than suggesting a straight relation of original and copies, point to a resemblance with the family trees of illuminated manuscripts: the various paintings representing this story appear divided into branches, each of which preserved a special and characteristic version of the iconographic tradition that formed their common stem.[21] In principle, the difference of artistic atti-

21. P. H. von Blanckenhagen, "Daedalus and Icarus on Pompeian Walls," *RM* 75 (1968) : 106–43.

tude which comes here to the fore is one between a process of continuity and an art of revival. Copying implies recourse to a particular exemplar, usually from the past; variations indicate the continuing presence of an active iconographic memory. Roman art obviously provided the conditions for either attitude, conscious revival as well as spontaneous continuity. The sequel of variants in the representations of a single myth, for instance the "Fall of Icarus," in Pompeiian painting can with reasonable probability be interpreted as a symptom of continuous, progressive transformation. The same gradualness apparently set the pace of change, generally, in the progressive Romanization of Hellenistic art.

The Illustrative Contents

The illustrative contents and their sources have of late received a more eager attention than the stylistically and art-historically directed inquiries, which led the discussion on Roman art in the first half of the century, were prepared to grant them. Further studies are obviously needed in this area. The key problems are not always the same, but differ depending on the various kinds of subject matter. Thus the mythologies which occur frequently among the wall paintings, less often in reliefs on decorated silver and other metal objects, present as a rule little difficulty of identification. Most show familiar stories and personages. The problems which they nevertheless raise stem from our lack of information regarding their artistic circumstances, connections, and sources. Being narratives, they must

have a literary or at any rate verbal basis of some kind. If the nature of their literary source can be established, this in turn will have a bearing on our judgment of their artistic character and possible prototypes. Episodes of drama must generally be regarded as textual illustrations, even though the actual play which they followed may not be known to us. Generically, they are more likely connected with other textual illustrations or illustrative series than with a single "masterpiece" of Greek painting.[22] Unless there is proof to the contrary, Roman representations of this type may be considered the outcome of continued traditions, perhaps of Hellenistic origin, the purpose of which was to illustrate literary texts. They are themselves illustrations without script and, as such, an essentially anonymous art. Other narratives such as the Homeric friezes found in Pompeiian houses seem to represent a related category of illustration, though the underlying texts were probably epic rather than dramatic. In illustrations of either genre, the epic or the dramatic, consecutive events of a progressive action can be amassed in a panel composition instead of a frieze; the result in that case is a special—characteristically Roman—type of "continuous narration.[23] At any rate, in all instances of mythical narrative belonging to one or another of the above categories, it is necessary to contemplate a twofold set of sources. One consists in the literary model that shaped the story as the artist recounted it; the other, in the iconographic traditions

22. K. M. Phillips, "Perseus and Andromeda," *AJA* 72 (1968) : 1–21.

23. P. H. von Blanckenhagen, "Narration in Hellenistic and Roman Art," *AJA* 61 (1957) : 78–83.

that prefigured his version, as rendered. It must of course be conceded that in Roman and probably also in earlier art, a mythological representation could have been based on a certain text directly. But the indications are that most narrative subjects in Roman art reached the artist through the medium of established iconographic traditions which only ultimately, at their remote and perhaps, to us, unknown origins, derived from a textual illustration. Such close agreement of text and image, and the ensuing literalness of the work of art, apparently was a postclassical development. The Greek artists of the sixth and fifth centuries B.C. used to treat their mythologies more liberally, as shown by the painted vases, which seem to vie with the freedom of fiction in the literary arts rather than relying on them. The ascent of literary illustrations in effect introduced a new species of representational art.

Further information about the genetic lines that may connect narrative themes in Roman art with illustrated literary texts must come from new research. The fact that a large segment of Roman art shared its themes with literature is sufficiently clear, anyhow. Nor is this obvious observation valid only with respect to the store of Greek myths which the artists adapted to their proper purposes, much as the same myths were utilized and eventually capsulated in the Latin poetic literature. It applies as well to the representations of history and of current events, or of religious ritual such as that shown in the large frieze in the villa "of the Mysteries." [24] All these themes contain an element of

24. O. J. Brendel, "Der grosse Fries in der Villa dei Misteri," *Jdl* 81 (1966) : 206–60. G. Carettoni, "Il fregio figurato della Basilica Emilia," *RivIstArch* 10 (1961) : 5–78. E. Nash, *Pictorial Dictionary of Ancient Rome*, vol. 2 (New York, 1962), bibliography pp. 359–69.

narration, and hence presuppose a verbal exposition to become wholly intelligible. In dealing with them Roman art shows a literary bent not essentially different from the avowed literacy of Greek art. What nevertheless separates Roman from Greek thinking, even within this humanistic field which both arts cultivated, was due to differences of content, outlook, and social circumstances in the literatures that provided the intellectual complement of either. In Latin letters a Greek myth rarely is a story simply told. More often than not it is quoted as a link in a broader context, as in Ovid's *Metamorphoses;* it serves as a rhetorical adornment, a moral illustration, or some other exemplification of concept. In this trend Roman art followed suit: one of its characteristics—perhaps the most distinctive—was its penchant for allegory. For the resort to allegory reflects a desire to expand the reach of art beyond the visible and tangible reality of things into the realm of the invisible: of ideas, notions, sentiments. It aims at connotations and veiled meanings behind the obvious data of sense. As a method of visual art allegory has the power to express abstractions and to instruct; at the same time it may foster a sense for the arcane. In either way it appealed to inclinations which were deeply imbedded in the Roman intellectuality, as they also were of old in the Roman religion.

Allegory, The Cryptic Vision

Allegories, by necessity, create other problems than do the straightforward mythologies. In Roman art allegories occur most frequently in connection with politi-

cal themes. Apparently we ought to recognize them as free inventions of art or as variations of iconographic types, not supported by any particular literary text; though literary parallels of their imagery can often be found.[25] Consequently they share with the mythologies the appeal to literate comprehension, as indeed they borrow from the latter many of their standard personifications. It follows that the Roman political allegories represent a special branch of art, distinct from the mythologies, although they must be regarded as members of the same intellectual family. The pictorial idiom, if not always the themes, are Latin in either case. We may call the painted mythologies—excepting demonstrable copies of classical masterpieces—latinized Greek subjects, and the political allegories which appear mostly in reliefs, hellenizing Roman topics: the difference is one of kind, not substance.

The mythological illustrations, even, do not altogether lack allegorical innuendoes, as we noted above. Thus the stories represented on the sculpted sarcophagi of the second and third centuries A.D. can hardly fail to evoke the thought of death, and certainly often did so. For instance, the departure of Theseus from the sleeping Ariadne may be read as an analogy of the common simile likening death to a journey. The difficulty in modern studies of such possible associations arises from the danger of overinterpretation, which allegory invites by its nature. This also seems to be true of the related question, which lately was raised several times, regarding the selection of mythical or

25. T. Hölscher, *Victoria Romana* (Mainz, 1967). P. Zanker, *Forum Augustum* (Monumenta Artis Antiquae II, Tübingen, 1968), pp. 14, 20.

religious themes for the decoration of Pompeiian houses and other architectural interiors. As in these decorative arrangements the illustrative elements frequently appear in numbers of two or more, as sequels, for instance facing each other on the walls of the same room, one may legitimately ask if their subjects were assembled at random or for arbitrary reasons of utility and taste; or if, on the contrary, their combination reflects a meaningful program. In the latter event the context of the whole group will elicit from the separate paintings a secondary meaning, common to all its members; as in the large oecus of the villa from Boscoreale the ensemble of famous lovers, copied from Hellenistic prototypes, probably exemplified the sway of Aphrodite by a series of appropriate, legendary episodes.[26] Semiliterary programs of this sort may be expected, with reason. They were in keeping with the methods of Latin poetry, as well as the practice of art collectors.[27] Allegorizing representations of myths or other narratives actually do occur at various stages of Roman art, either in the form of picture series collected under a silently assumed, moral heading, or as allusive images which derive their allegorical connotations from a portentous carrier such as the sculpted sarcophagi. The habit was still alive in early Christian art, which revitalized the old modes of allegory and cyclical narrative by new contents and a new set of symbols.

These forays of the visual arts into the realm of in-

26. Ph. W. Lehmann, *Roman Wall Paintings from Boscoreale in the Metropolitan Museum* (Cambridge, Mass., 1953). Review, O. J. Brendel, *AJP* 75 (1954) : 407ff.
27. Pollitt, *Art of Rome,* pp. 74–81.

visible thought could not fail, over the centuries, to accommodate their aims and methods to the different moods of the successive generations. In recent years suggestions have been forthcoming to divide the history of Roman art into periods according to such data of the history of ideas as the increasing abstractness of meaning, in its allegorical imagery. Proposals of this order have the merit to promise a system of periodization that would regard all components of art, active within a certain span of time, instead of basing its validity on only one class, such as the official monuments. Doubts arise, nevertheless, from the inevitable arbitrariness of modern judgments on which such historical constructions must be grounded. A critical method which arranges works of art as documents of intellectual history bases itself on interpretations of meaning and intent. Yet, for instance, among representational subjects in architectural settings to distinguish between forthright narratives, series with a veiled allegorical intent, and bona fide decorations with only the slightest claim to sense, becomes a risky task; especially so in an art which, like the Roman, tends to fuse the elements of fact and fancy with uncommon ease. In this field much preparatory work has yet to be done. The themes and contents of Roman art still leave ample room for argument and fresh evidence; so do their various levels of meaning. The full harvest is not yet in.

The last remark must be applied, with equal right, to the political allegories as well. It is true that in this group the allegorical character of a representation is rarely, if ever, in doubt. The presence of obvious personifications or well-known characters of mythical fic-

tion is its distinctive mark. Interspersed with the actions of actual people these visitors from a world of fancy create incongruent situations; witness the large Augustan cameo at Vienna.[28] The difficulty and the attraction as well that inhere in these pictured capriccios arise in part from the interpretation of the signs and images, but also from the seeming absurdity of their combinations. In Rome apparently the allegories of this description were an Augustan innovation; their possible antecedents, for instance in the aulic art of Ptolemaic Egypt, are as yet insufficiently known. Their original theme was the Roman institutions under the Empire; their general tendency, to transpose the actual political body into an image of semimythical order functioning as the terrestrial analogue of the cosmic organism. A change of emphasis in the political allegories seems to have taken place about the middle of the second century A.D. when their number and the variance of their imagery began to dwindle and be replaced by a more factual, standard iconography of the prescribed imperial tasks.[29] Even then, while the events in reality which underlay these representations may be often named or at least hypothetically identified, the recent literature clearly shows the manifold difficulties which to this day beset their explanation. This rather negative conclusion may surprise us, since the monuments in this vein include the most widely known, and most intensely studied, works of Roman art. Yet of the problems which they pose, not many can be considered solved. The principal merit of the

28. Kähler, *Rom und Seine Welt*, pp. 186–8.
29. R. Brilliant, *Gesture and Rank in Roman Art* (New Haven, 1963), pp. 105–61.

latest studies which deal with these allegorizations of Roman history and their concomitant philosophies of government, seems to lie in their catalytic effect: they tend to bring the uncertainties to light, by questioning former answers or correcting faulty observations, as the case may be. This challenge to solutions that have seemed acceptable in the past but do not seem so now is likely to continue. It forces us to caution, and to admit that about many works in this class, some of the most outstanding amongst them, not much can be taken for granted; agreement has not yet been reached because the accounts given so far still contain too many unknowns. Even monuments as famous and seemingly accessible as the Ara Pacis Augustae have kept most of their secrets. The significance of the procession; Augustus's own action; the meaning of the so-called Tellus relief: all constitute unsettled questions awaiting further elucidation.[30] But no less surprising than are these uncertainties, in Roman monuments generally thought to be securely known, is the widening range of implied contents and connotations—allusions addressed to the informed contemporaries but easily escaping the modern student—which their discussions uncover. The Primaporta Augustus heads the catalogue of such problems of note, which we find tucked away in an imagery ostensibly obvious.[31] From there, the list extends across the centuries.

30. E. Simon, *Ara Pacis Augustae* (Monumenta Artis Antiquae I, Tübingen, 1967).
31. H. Ingholt, "The Prima Porta Statue of Augustus," *Archaeology* 22 (1959) : 176–87, 304–18. H. Kähler, *Die Augustusstatue von Primaporta* (Cologne, 1959).

The winged carrier too often called *Aion*, on the base for the Column of Antoninus, represents another item in this file of unsettled problems; so, it seems, does the recently discovered painted ceiling from the imperial palace in Trier, to name an example on the late-Roman level.[32]

Evidently the Roman literary mind took to these complexities of art, which turned their images into media of direct communication with the vagrant workings of the spirit. Their effective principle—the cryptic vision—was not reserved for the allegorical embodiment of political ideology alone. The same principle could be applied to a variety of topics, religious, moral, and literary, mythical storytelling included; thereby opening up, in each new instance, a different background of connecting ideas and reminiscences. An example of the latter kind which caused one of the most lively debates in recent years, on a matter of Roman art, is the Portland Vase.[33] Its frieze of large figures, cut from the top layer of the blue and white cameo-glass, evidently tells a story: a myth. Just

32. I. Lavin, "The Ceiling Frescoes in Trier and Illusionism in Constantinian Painting," *Dumbarton Oaks Papers* 21 (1967) : 99–113. W. Reusch, ed., *Frühchristliche Zeugnisse im Einzugsgebiet von Rhein und Mosel* (Trier, 1965), pp. 236ff.

33. E. B. Harrison, "The Portland Vase: Thinking it over," in *In Memoriam Otto J. Brendel, Essays in Archaeology and the Humanities*," eds. Larissa Bonfante and Helga von Heintze (Mainz, 1976), pp. 131–42. This essay offers, aside from important new research, a complete bibliography of the Portland Vase. Note 33 is an exception to the rule observed here whereby only those works are quoted which could have been known to the author when he finished his essay, December 1969. (Ed.)

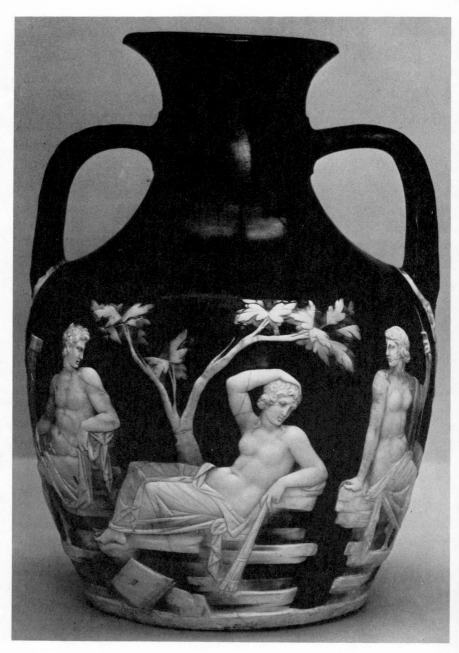

FIGURE 26
Two views of the Portland Vase, London, British Museum.

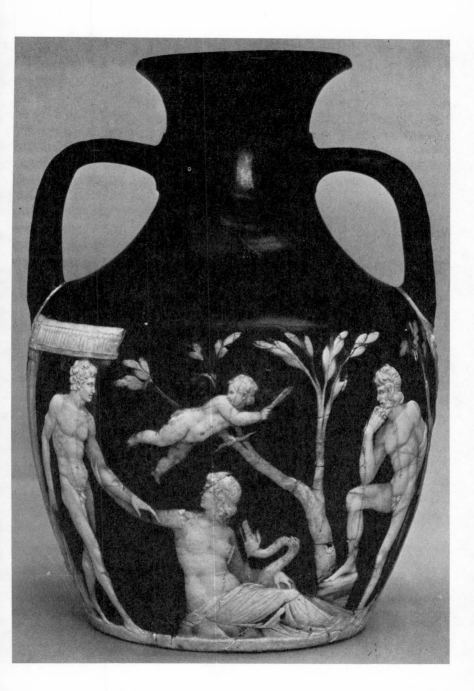

what the story might be is difficult to say, however, because it is told in so strange a manner. It has certainly puzzled its modern examiners, and may have astounded the ancient. In the opinion of this writer, of all heroic names that were suggested at one time or another to solve the riddle, Theseus probably has the best chance of proving correct. I share the opinion that only a single, well-known mythical episode is represented; and I think that this episode is the departure of Theseus from Naxos. The action is not visibly unified, however; it appears divided into two consecutive moments. In the first stage (fig. 26, *left*) Theseus sits brooding, his hand fidgeting with the garment he shall soon discard, his gaze fixed on the sleeping Ariadne. The seated woman on the yonder side may, but need not, be Aphrodite; she could represent the personification of the island. In the second stage (fig. 26, *right*) the decision has been made. Theseus slips stealthily into the water, on tiptoes; half drawn, half supported by the goddess with the sea-dragon, who most likely represents Amphitrite. She will deliver him to the Attic shore toward which she is turned and where her husband, Poseidon, waits thoughtfully, looking out from Cape Sunion. But what place has a Cupid in this scene, where love is so sorrily deceived? His presence poses a baffling question; but I believe that an answer can be given. As this Eros calls on the hesitant hero he points the way; and his is the way of a duty higher than affection. I regard him as the "Eros of the Good and Rightful whom the man of reason ought to follow"—and does follow, in this instance, "saying farewell to Kypris, the daughter of Zeus." The words and the implied comments on the myth belong

to Euripides.[34] The imagery and the manner of representation are Roman. Although, obviously, this highly original work has left the standard iconography of its so common subject far behind, it does not seem beyond understanding. One only has to realize that the hero is shown twice in a single and progressive action, in "continuous narration"; also, that the vehicle of his reluctant leave which one would normally expect to see—the ship—has been omitted, and replaced by allegory. The Cupid with the torch, who forms part of the allegory, is matched by many similar putti in Roman art. The torch naturally connotes light: night is on the wane, morning rises. If these observations hold, the Portland Vase ought to be listed as a Roman illustration of Euripidean drama, in this respect not unlike the newly acquired silver krater of the British Museum.[35] But the question whether some nearer source cannot be found in a latinized version of the Euripidean thought on a level, approximately, with the tragedies of Seneca, must also be left open. Its discussion lies beyond the bounds of this essay.

34. Euripides, fragment 388 (ed. Nauck); assigned to Euripides by T. B. L. Webster, The Tragedies of Euripides (London, 1967), pp. 105ff. Probably part of a speech (of Athena?) in Euripides's Theseus.

35. P. E. Corbett and D. E. Strong, "Three Roman Silver Cups," BMQ 23 (1960–61) : 68–83.

Index